T0346766

Ancient Egyptian Jewelry

50 Masterpieces of Art and Design

To the F-Js — Lucinda, Alexandra, and Huw

Photographs by *Araldo De Luca/Archivio White Star*

Graphic Design by *Maria Cucchi*

First published in Egypt in 2020 by
The American University in Cairo Press
113 Sharia Kasr el Aini, Cairo, Egypt
200 Park Ave., Suite 1700 New York, NY 10166
www.aucpress.com

Text © 2020 by Nigel Fletcher-Jones
Illustrations, design, and typography © 2020 by White Star s.r.l.
Published by arrangement with White Star s.r.l., Milan, Italy

Dar el Kutub No. 11153/19
ISBN 978 977 416 965 6

Dar el Kutub Cataloging-in-Publication Data

Fletcher-Jones, Nigel.
 Ancient Egyptian Jewelry: 50 Masterpieces of Art
 and Design / Nigel Fletcher-Jones.—Cairo: The American
 University in Cairo Press, 2020.
 p. cm.
 ISBN 978 977 416 965 6
 1. Jewelry, Ancient—Egypt
 2. Egypt—Antiquities
 932

1 2 3 4 5 24 23 22 21 20

Printed in Turkey

Ancient Egyptian Jewelry

50 Masterpieces of Art and Design

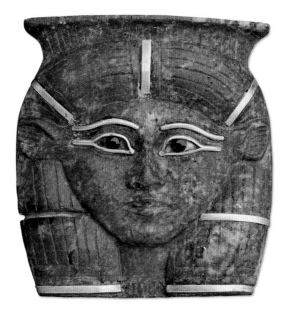

Nigel Fletcher-Jones

The American University in Cairo Press
Cairo New York

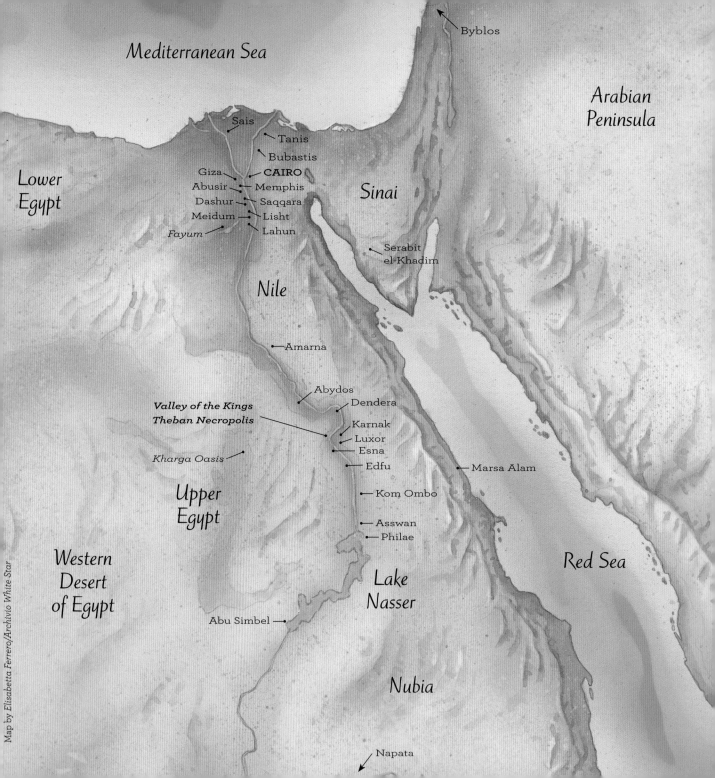

Mediterranean Sea

Arabian
Peninsula

Byblos

Lower
Egypt

Sais

Tanis

Bubastis

Giza **CAIRO**

Abusir Memphis

Dashur Saqqara

Meidum Lisht

Fayum Lahun

Sinai

Serabit
el-Khadim

Nile

Amarna

Abydos

Valley of the Kings
Theban Necropolis

Dendera

Karnak

Luxor

Esna

Kharga Oasis

Edfu

Upper
Egypt

Kom Ombo

Asswan

Philae

Marsa Alam

Red Sea

Western
Desert
of Egypt

Lake
Nasser

Abu Simbel

Nubia

Napata

Map by Elisabetta Ferrero/Archivio White Star

Contents

Introduction

Writing later, Howard Carter recalled peering through the first breach he had made in the top left-hand corner of the second sealed door to Tutankhamun's tomb and seeing "everywhere the glint of gold."

That same spectacular glint is one of the defining features of the ancient Egyptian jewelry masterpieces in this book—all of which can be seen within Cairo's archaeological museums in a few days. Indeed, a variety of combinations of gold and semi-precious stones—most often carnelian, turquoise, and lapis lazuli—characterized the jewelry of kings, queens, princesses, and officials for two thousand years.

The majority of gold used to make jewelry came from the central and southern parts of the Egyptian desert to the east of the Nile, and particularly—during parts of the period known to us as the New Kingdom (1550-1069 BC)—from the eastern part of lower Nubia (modern northeastern Sudan). The word Nubia may, indeed, be derived (directly or indirectly) from the ancient Egyptian word for gold, nwb.

Gold mining—as opposed to the collection of gold-bearing rocks from the beds of streams—began some time before Egypt was united under a king around 3100 BC. The extraction technique was simple and labor-intensive: the gold-bearing quartz was simply pounded with stone hammers to free slivers of the precious metal. By the New Kingdom, if not before, stone washing-tables were used which may have made use of sheep skins to trap gold particles—the Egyptian 'golden fleece' may have predated the one sought by Jason and the Argonauts by many centuries.

Although both the ancient and modern perceptions are that gold was available in limitless quantities in ancient Egypt, the total amount produced within Egypt was quite modest (perhaps 6,000 kg [around 13,000 lbs] from the small mines and a further 7,000 kg [around 15,500 lbs] from surface deposits), though we cannot estimate additional amounts that may have entered Egypt from other sources by trade, tribute, or conquest as the Egyptian Empire expanded to the south and into the Levant. By the Roman period, a combination of exhaustion of retrievable deposits, which had been mined by then for several thousand years, and the presence of hostile tribes in the Egyptian desert brought gold prospecting and processing to its lowest point in the state's history.

As a result, one reason why a relatively small number of jewelry pieces have survived from ancient Egypt is simply that, over the centuries, gold and precious stones were reused or recut many times, often with the implicit encouragement of the Egyptian authorities, if the original

pieces came from rich burials. Put simply, the glittering gold of Tutankhamun's tomb represents a rare case in which hard-won metal and gemstones were removed by fate from further circulation.

As there were few local sources of silver (hedj) in Egypt, the already precious metal appears to have been more highly valued than gold in the earliest periods. It was principally derived from gold/silver alloys, or as a by-product of lead mining within Egypt, but the majority of the metal—from the Middle Kingdom onward—is likely to have come from neighboring lands. As sheet silver, in particular, is more susceptible to corrosion in burials than gold or copper, it is possible that it was used more often in jewelry than we can now observe, and, certainly by the New Kingdom, we are aware from temple inscriptions that enormous quantities of silver were being imported into Egypt. Silver (or 'white gold') was closely associated with the moon, as gold was associated with the sun.

Around forty different types of gemstone (the nearest equivalent word in Egyptian is aat, meaning 'a mineral of value') were used in the surviving pieces of ancient Egyptian jewelry—many making their appearance only with the arrival of the Greeks and Romans, when they were imported from elsewhere. Of these semi-precious stones, the most popular was orange-red or red carnelian (herset). While, over time, popular stones might be imitated often by the use of glass paste or clear rock crystal over paint, the ancient Egyptians still continued to prefer to use genuine carnelian in very large quantities—so large, in fact, that it is unlikely that the known sources of the stone (including at Stella Ridge—about eighty kilometers (fifty miles) northwest of the famous rock-cut temples at Abu Simbel) could have met demand over the centuries. Additional supplies may have come from the Nile terraces in Nubia near Wadi Halfa (in modern Sudan), but it has been suggested that some may have come from the far distant deposits in modern India's Gujarat state where the stone had been mined since about 3000 BC. (Medium to dark red jasper [heken], probably from the eastern desert, was also commonly used in ancient Egypt, though no mine is known.)

Light green, medium green, and greenish-blue turquoise (mefkat), by contrast, came from mines in the southwest of the Sinai Peninsula—Wadi Magram from the Early Dynastic Period to the Middle Kingdom, and Serabit el-Khadim from (at the latest) the Middle Kingdom to the Late Period, though the principal activity here may have been mining for copper. Nonetheless, at Serabit el-Khadim many inscriptions are dedicated to the ancient goddess Hathor as 'mistress of turquoise.'

Sometimes confused with turquoise, light green, medium green, or bluish-green feldspar (or amazonite; in Egyptian, neshmet) could also sometimes provide a complementary color to turquoise and lapis lazuli. Two mines dating from the New Kingdom and Greco-Roman Period are known from the Red Sea coast not far from Marsa Alam, but there may have been earlier sources in the area.

Although dark blue lapis lazuli (khesbed) is intimately connected with ancient Egyptian jewelry, it is doubtful if any of the stone was mined within Egypt. The primary ancient source was the region of Badakhshan in northeast Afghanistan, which lay at the beginning of a great trade network across western Asia—the stone most likely coming to Egypt through the port of Byblos, now in modern Lebanon.

The colors associated with many of these stones had symbolic or magical significance that accounts in part for their enduring popularity in jewelry. The red and red-orange color of carnelian was naturally associated with vitality and the sun; the light blue of some forms of turquoise reflected the daytime sky and the waters from which all things were thought to have emerged at the creation; the green and blue-green of feldspar, and other forms of turquoise, recalled new growth along the banks of the Nile after the annual flood, and a comparable promise of resurrection in the afterlife; and the dark blue of lapis lazuli represented the protective night sky. Indeed, the color of a stone (or its imitation in manufactured ceramic faience or glass) seems to have been more important from a magical perspective than the value or rarity of the genuine stone. The horizontal bands of the nemes headcloth of the funerary mask of Tutankhamun, for example, are made simply of glass paste in imitation of lapis lazuli, not the stone itself.

Of the other gemstones which appear in the following pages, their popularity came and went with the centuries: amethyst (hesmen) was commonly mined and used in Middle Kingdom and Greco-Roman Egypt; and red garnet (hemaget) was used rarely in the pharaonic periods, but commonly in the Greco-Roman period. Indeed, many stones were used occasionally in ancient Egyptian history, but more commonly in the Ptolemaic and Roman periods, including common agate, onyx, sardonyx, aquamarine, sapphire, and emerald (the emeralds mined in Egypt, the sapphires imported from the east—particularly from India).

From the isolated mines in the desert, the raw gemstones would be carried to workshops where, most often, they were converted into beads, not least because—until almost the end of ancient Egyptian history—the jewelers possessed nothing harder than chert, flint, quartzite, sandstone, or sand itself with which to work the stones.

The gems would be first chipped and laboriously ground into rough shape, and then beads would be drilled through by a hand- or bow-drill with a hard stone bit. Carving and

engraving of other objects no doubt involved broadly similar techniques. Polishing was probably accomplished using a hard, flat rock surface and very fine sand, or fine sand paste rubbed onto larger objects with leather or cloth.

While the most frequent use of gemstones was beads, they could also be used to form amulets that, alongside those made from other materials, were most often intended to protect the wearer from hostile unseen forces—in life or in death (though a separate set of funerary amulets was used specifically in the protection of a mummy).

A Note on Dates

Prior to 690 BC, there are no exact dates of events in ancient Egyptian history.

In their writings, the ancient Egyptians measured the annual passing of time only by 'regnal years'—the number of years the current king had sat on the throne.

Around the year 300 BC, Manetho, an Egyptian priest writing in Greek, attempted to bring order to the long royal history of ancient Egypt by grouping kings into thirty dynasties based on the familial or political ties of pharaohs.

There have been arguments about this list ever since: we believe some listed kings probably did not exist; and some, who we know from the archaeological record did exist, are not present in the list. This does not provide a firm basis for establishing the reigns of individual pharaohs with any degree of precision. As a result, the great king Rameses II, whose name can be seen carved in stone from one end of Egypt to the other, will be said in this book to have reigned between 1279 and 1213 BC, but the reader may also see the spans 1290–1223 BC and 1265–1200 BC stated in other books with equal conviction.

In the great timespan occupied by the Egyptian state, such tiny discrepancies must surely be forgivable.

In addition to dynasties, Egyptologists make use of broader divisions of Egyptian history starting with the formation of the Egyptian state in the Early Dynastic Period (approximately 3100–2686 BC), followed by the Old Kingdom (2686–2181 BC); an unsettled period known as the First Intermediate Period (2181–2055 BC); the Middle Kingdom (1985–1650 BC); another unsettled period known as the Second Intermediate Period (1650–1550 BC); the New Kingdom (1550–1069 BC); the Third Intermediate Period (1069–747 BC); and the Late Period (747–332 BC), which saw the increasing involvement of the Persian Empire until it took control of Egypt directly in 342 BC. The Persians were defeated in 332 BC by Alexander the Great, who inaugurated the Hellenistic Period (332–30 BC), including the rule of the Greek Ptolemies (305–30 BC), which lasted until the Roman Period of 30 BC to AD 395. For convenience in this book, these last two periods are sometimes combined as the Greco-Roman Period.

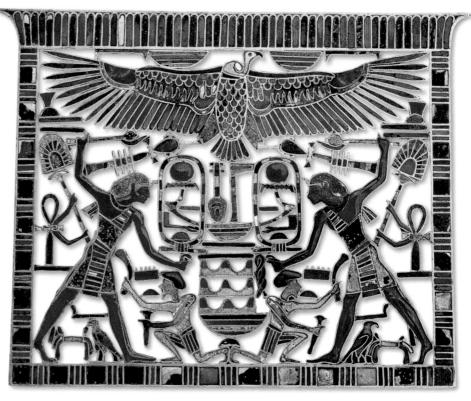

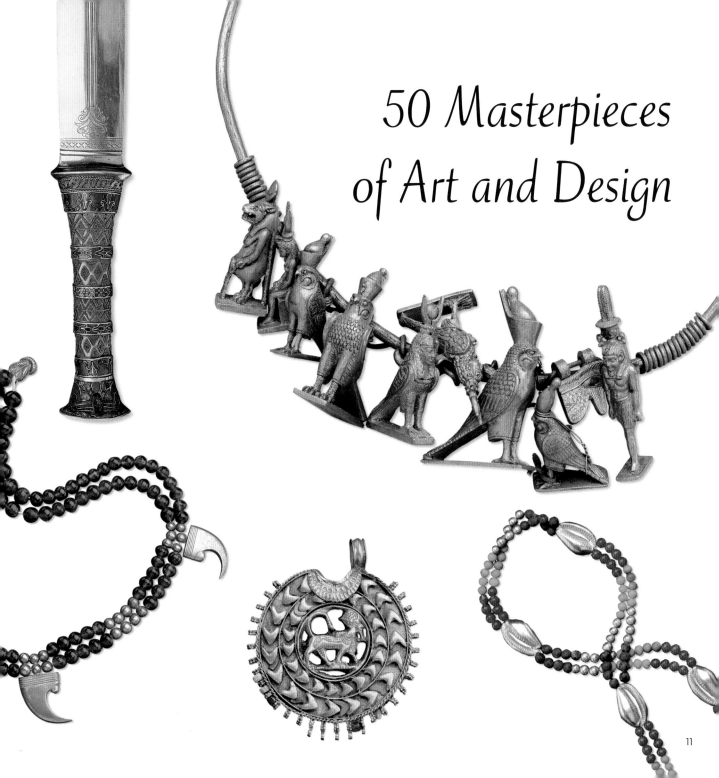

50 Masterpieces
of Art and Design

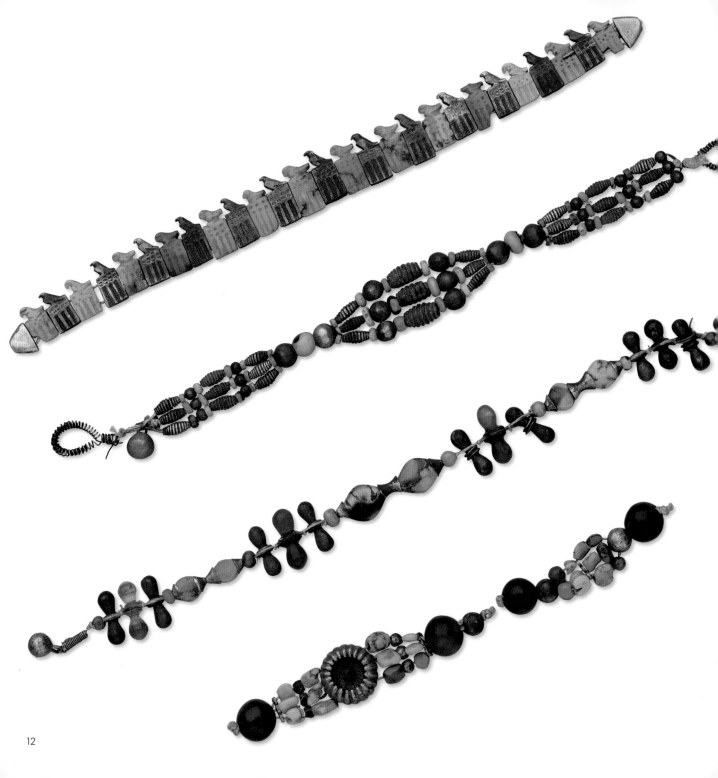

The Bracelets of Horus Djer

Materials: Gold, turquoise, lapis lazuli, amethyst, limestone
Dimensions: Bracelets — (l) 10.2–15.6 cm (4.01–6.14");
serekh bracelet — (wt) 22 gm (0.78 oz)
Current location: Egyptian Museum, Cairo
Original location: Tomb O (Djer), Umm el-Qa'ab, Abydos
(excavated by Petrie in 1901)
Dynasty: 1st, 3100–2686 BC, Early Dynastic Period
Reign: Horus Djer (around 3040 BC)
Owner: Probably an unknown queen
Museum entry: JA 35054a–d, CG 52008–52011

These rare bracelets date to the period soon after the unification of Upper (southern) and Lower (northern) Egypt around 3100 BC. They were found together on a mummified arm that had been hidden in the wall of the tomb of King Djer at the royal burial site at Abydos in southern Egypt. The arm may have been placed there by tomb robbers who did not return, for whatever reason, to claim their prize.

The upper bracelet is composed of twenty-nine beads of gold and turquoise showing a falcon perched above a representation of a royal palace (an early way—known as a *serekh*—of representing the king's name, used before the more familiar royal cartouche). The small rectangles below the falcon may have been intended to loosely represent the name of Djer. The pieces of this bracelet are marked on the bottom to show how they were intended to be arranged.

The second bracelet is made of matching coiled gold wire and grooved lapis lazuli beads. These elements are separated by gold and turquoise ball beads, and turquoise disc beads.

Below this is an unusual bracelet composed of gold and amethyst hourglass-shaped beads (one is brown limestone) and lens-shaped turquoise beads, with a gold cap at one end and gold reels at the other. The hourglass beads are held in place by thread wound around a double groove.

The centerpiece of the final bracelet is a rosette (gold foil over a core of material) in the form of a lotus-seed pod. To either side are polished and pierced turquoise chips, hollow gold beads, and lapis lazuli spheres.

The underside of the bracelet is similarly constructed, but without the rosette.

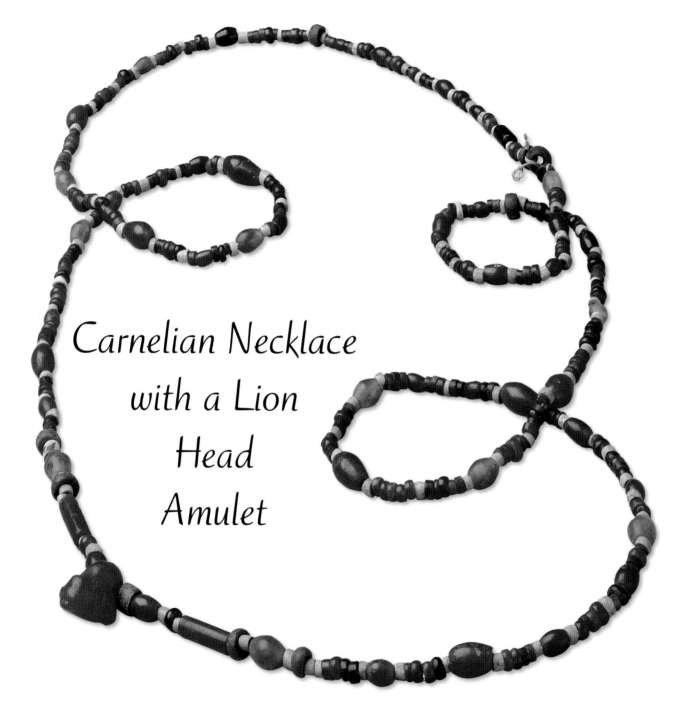

Carnelian Necklace
with a Lion
Head
Amulet

Materials: *Carnelian, amethyst, garnet, turquoise, lapis lazuli, Egyptian faience*
Dimensions: *(l) 94 cm (37")*
Current location: *Grand Egyptian Museum, Cairo*
Original location: *Zawyet el-Aryan, near Giza*

(excavated by Fisher and Reisner in 1910–11)
Dynasty: *Possibly 3rd Dynasty, 2686–2613 BC, Old Kingdom*
Reign: *Unknown*
Owner: *Unknown*
Museum entry: *JE 43127, GEM 516*

Djer's predecessor, King Aha (around 3085 BC), is thought to have established the great royal city of Memphis (to the southwest of modern Cairo) shortly after the unification of Upper and Lower Egypt. The name of the central temple at Memphis dedicated to the god Ptah, *Hwt-Ka-Ptah*, was sometimes used to describe the whole city, and, through its transliteration as *Aigyptos* in Greek, eventually gave its name to Egypt.

Over three thousand years, Memphis remained important, though its fortunes rose and fell, and its central location changed. In the Early Dynastic Period (3100–2686 BC), the city may have spread widely over both banks of the Nile—a suggestion strengthened by the presence of a 100,000-grave cemetery found at Helwan on the east bank, and the importance of known major trade routes to the east of the river.

This necklace—from a tomb at Zawyet el-Aryan between Giza and Abusir—serves as a reminder that jewelry was an important part of everyday life for all women, men, and children, not least for its magical properties. It also represents an early testament to the particular importance carnelian was to play in jewelry throughout ancient Egyptian history.

The red of carnelian and other red stones (particularly the similar stone sard, and red jasper) was naturally associated with blood, vitality, dynamism, power, and, in carnelian's red and orange-red forms, the sun. By later extension, this association extended to the sun god Re, the falcon god Horus, and the goddesses Hathor and Sekhmet (among others) who shared the attribute of being an 'eye of Re.'

An amulet of a lion's head completes the necklace, and, through this, the wearer might be protected from the animal or might absorb some of its powers. Those powers, and more, were to combine into a number of fearsome, but sometimes protective, lioness goddesses including Sekhmet, Tefnut, Menhyt, and Bastet—who became usually represented as a cat in later periods of Egyptian history.

The Butterfly Bracelets of Queen Hetepheres

Materials: Silver, carnelian, turquoise, green jasper, lapis lazuli, colored plaster
Dimensions: Bracelets — (d) 9–11 cm (3.54–4.33"); gilded wood casket — (h) 21.8 cm (8.58"), (l) 41.9 cm (16.50"), (w) 33.7 cm (13.27")
Current location: Egyptian Museum, Cairo
Original location: Shaft G7000X, Giza Plateau
(excavated by Reisner in 1925)
Dynasty: 4th, 2613–2494 BC, Old Kingdom
Reign: Seneferu (2613–2589 BC), Khufu (2589–2566 BC)
Owner: Queen Hetepheres I, wife of Seneferu and mother of Khufu
Museum entry: JE 53265, JE 53266

Queen Hetepheres was the wife of Seneferu—builder of the Meidum, Bent, and Red Pyramids—and the mother of Khufu (in Greek, Cheops), the builder of the Great Pyramid at Giza. Her grave goods and sarcophagus were found in a shaft near to one of the small pyramids (G1-a) close to the Great Pyramid. The sarcophagus was empty, leading to speculation that the queen's final resting place was the small pyramid close to her son, or that she was buried near her husband at Dahshur's Red Pyramid.

Twenty silver bracelets in this butterfly motif were found in the decayed remains of a gilded wooden box labeled, 'box containing rings . . . Mother of the King of Upper and Lower Egypt, Hetepheres.' An image of Hetepheres on one of her chairs found nearby shows her with fourteen similar, but plain, bracelets on her arm.

These bracelets were made from sheet silver beaten over a stake to turn the edges, leaving the inside open—an already ancient technique. The outer side is decorated with four butterfly designs inlaid with semi-precious stones (turquoise, lapis lazuli, carnelian, green jasper) cemented next to one another in a depression in the silver. Colored plaster was used to fill in gaps and a number of carnelian disks completed the design.

First seen in these bracelets, the combination of carnelian, turquoise, and lapis lazuli was to characterize much of ancient Egyptian jewelry for the next two thousand years.

A few centuries later, the reign of the long-lived king Pepy II (2278–2184 BC) effectively brought the Old Kingdom to an end. Egypt was to descend shortly afterward into a chaotic period known to historians as the First Intermediate Period (2181–2055 BC).

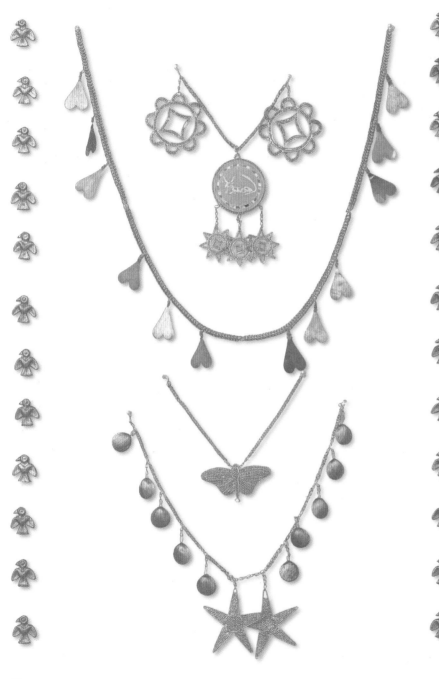

Jewels of Princess Khnemet

Egypt became united again under Montjuhotep II (2055–1985 BC), whose reign set in motion the period known as the Middle Kingdom (1985–1650 BC), which was consolidated under Amenemhat I (1985–1955 BC), not least by establishing a new capital—the city of Amenemhat Itjtawy, 'Amenemhat, seizer of the two lands,' near modern Lisht to the southwest of modern Cairo. Itjtawy was to remain the main residence of the king for four hundred years.

Princess Khnemet, a daughter of Amenemhat II (1922–1878 BC), was buried with a suite of jewelry that contains some of the most beautiful

Materials: Gold with applied granules and thread, frit
(a basic form of blue or green ceramic), rock crystal
Dimensions: Medallion—(d) 2.85 cm (1.12"), (wt) 6.6 g
(0.23 oz); necklace—(l) 27.8 cm (10.95"); butterfly clasp—
(h) 1.4 cm (0.55"), (w) 2.7 cm (1.06"); star pendants—
(w) 2.5 cm (0.98"), (wt) 6.3 g (0.22 oz); bird ornaments—
(w) 1 cm (0.39"), (wt) 0.6 g (0.02 oz)
Current location: Egyptian Museum, Cairo
Original location: Double tomb of Princesses Khnemet and Ita,
funerary complex of Amenemhat II, Dahshur
(excavated by de Morgan in 1894)
Dynasty: 12th, 1985–1795 BC, Middle Kingdom
Reign: Amenemhat II (1922–1878 BC), Senwosret II
(1880–1874 BC)
Owner: Princess Khnemet, a daughter of Amenemhat II and probable
wife of Senwosret II
Museum entry: JE 31126, JE 31124, JE 31127, JE 31125, JE 31121,
CG 52975–52979

pieces ever made in ancient Egypt including anklets, bracelets, pendants, and openwork diadems.

The collection of pendants, necklaces, and wig or hair ornaments shown here is particularly remarkable for its use of tiny granules of gold and gold wires (created by attaching gold granules together). The granules were attached to the pieces using a combination of wax and copper salts. When heated, the melted copper fused the pieces to the gold plates. This technique was probably introduced to Egypt during the Twelfth Dynasty (it originated in Mesopotamia over five hundred years before). Indeed, although presumably created by Egyptian craftsmen, this set of jewelry may have been influenced by Syrian and Minoan jewelry styles and craftsmen.

The medallion at the top is made of blue ceramic composite (blue frit) and contains the image of a cow or calf lying down. The medallion is covered with a thin rock crystal cover and surrounded by a gold frame from which hang three star-shaped pendants, outlined in gold granules, and attached with thin gold wires. Above are two openwork rosettes.

Below this is a necklace composed of a double-loop gold chain of twelve stylized bees or flies.

Reminiscent of Hetepheres' bracelets, the third chain has a clasp in the form of a butterfly—the details marked out by gold wire and then filled with gold granules.

The lower bracelet is composed of ten 'cockle-shell' pendants created in two parts from gold foil and wrapped around a core of unknown material, and two five-pointed stars or starfish—all suspended by short links from a double loop-in-loop gold chain.

On either side of the necklaces are small-bird ornaments for the hair or wig made from gold foil pressed in a mold and then soldered to a flat plate with two holes in it to allow the pieces to be threaded onto the hair of the wig.

Khnemet's Motto Bracelets

Materials: Gold, carnelian, lapis lazuli, green feldspar
Dimensions: Fasteners—(h) 1.8 cm (0.71"), 2.7 cm (1.06"),
1.7 cm (0.67")
Current location: Egyptian Museum, Cairo
Original location: Double tomb of Princesses Khnemet
and Ita, funerary complex of Amenemhat II, Dahshur
(excavated by de Morgan in 1894)
Dynasty: 12th, 1985–1795 BC, Middle Kingdom
Reign: Amenemhat II (1922–1878 BC), Senwosret II
(1880–1874 BC)
Owner: Princess Khnemet, a daughter of Amenemhat II and probable
wife of Senwosret II
Museum entry: JE 31114a–b, d, CG 52958, CG 52956, CG 52955

By contrast to Princess Khnemet's gold necklaces and pendants, her bracelets—possibly worn originally high up as an armlet on a cord—were thoroughly Egyptian and spell out appropriate mottos providing magical protection.

Amulets—often made from the simplest of materials and poorly formed in molds—were carried by all ancient Egyptians. By magical means, they protected the wearer from the dangers of the natural world or allowed him or her to absorb the characteristics of an animal or a deity. They might also give the wearer a particular power or a specific protection. Motto bracelets such as these, which required an understanding of the meaning of the symbols, were worn for similar purposes by the elite.

The symbols on the left bracelet fastener are the *sa* sign of magical protection (a folded reed mat shelter), followed by an ankh sign meaning 'life,' and the *ha* papyrus sign indicating 'behind,' above the *neb* basket sign meaning 'every'—the whole meaning 'all life and protection are behind (her)!' The middle fastener is in the form of a *meset* 'apron' made of three fox skins tied together and associated (through the *ms* value of the hieroglyph shared with the verb 'to give birth') with the protection of the wearer and with the birth process.

The right-hand fastener combines the *au* sign of part of the spine with spinal fluid that means 'length' (but can also mean 'joy'), above the *ib* heart symbol which means here 'wish, desire, or mood.' The whole is best translated as meaning 'joy (to the wearer)!'

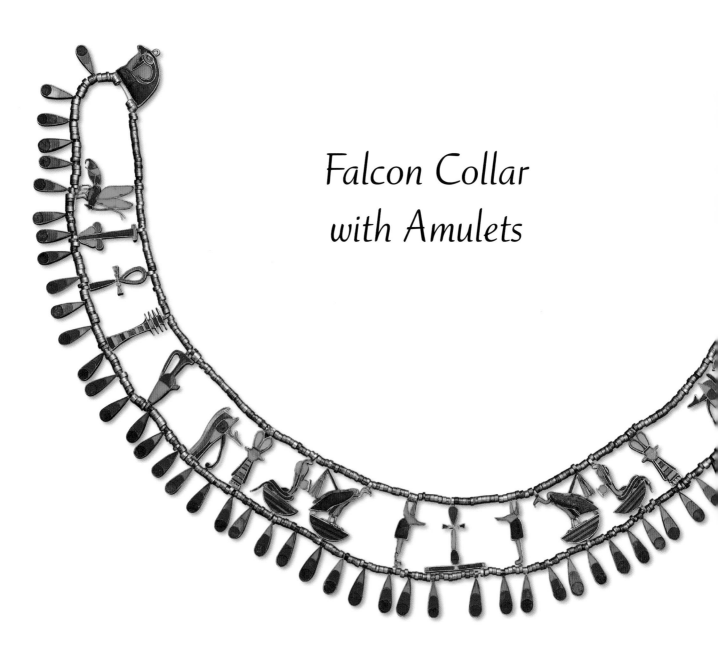

Falcon Collar
with Amulets

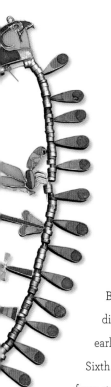

Materials: Gold, carnelian, turquoise, lapis lazuli
Dimensions: (l) 35 cm (13.78″)
Current location: Egyptian Museum
Original location: Double tomb of Princesses Khnemet
and Ita, funerary complex of Amenemhat II, Dahshur
(excavated by de Morgan in 1894)
Dynasty: 12th, 1985–1795 BC, Middle Kingdom
Reign: Amenemhat II (1922–1878 BC), Senwosret II (1880–1874 BC)
Owner: Princess Khenemet, a daughter of Amenemhat II
and probable wife of Senwosret II
Museum entry: JE 31116, CG 52018

Broad collars (*weskhet*) are perhaps the most distinctively Egyptian type of jewelry, and the earliest examples to have survived date to the Sixth Dynasty—though earlier collars are known from statues. They are composed of multiple strings of beads (often of glazed composition or 'Egyptian faience') that are graded in size and hung vertically. The strings are drawn in under a semicircular or falcon-headed terminal to emerge again as a single string around the neck. The lower edge of the collar may be completed by long leaf-shaped beads, sometimes strung between two rows of horizontal beads.

The magnificent openwork collar pictured here was reconstructed from pieces found on the mummy of Princess Khnemet and is composed of two strings of gold beads held at either end by falcon-head fasteners.

Within the two strings lies a set of symmetrical protective amulets centered on an ankh life symbol standing on a *hetep* offering-table sign ('peace'). From the outside to the center the amulets are a bee (a symbol of Lower Egypt), the *sma* (lungs and trachea) sign symbolizing 'union' (of Upper and Lower Egypt), the ankh sign, the *djed* (the spine of Osiris) sign symbolizing 'stability,' the *khenem* vase sign symbolizing 'unite,' the powerfully protective *wedjat* eye of Horus, the emblem of the goddess Bat (an ancient cow goddess with the ears and horns of a cow), the cobra goddess Wadjet of Lower Egypt and the vulture goddess Nekhbet of Upper Egypt (the 'two ladies'—both standing on a *neb(et)* basket indicating each as a 'lady'), and the jackal-headed user symbol signifying 'power.'

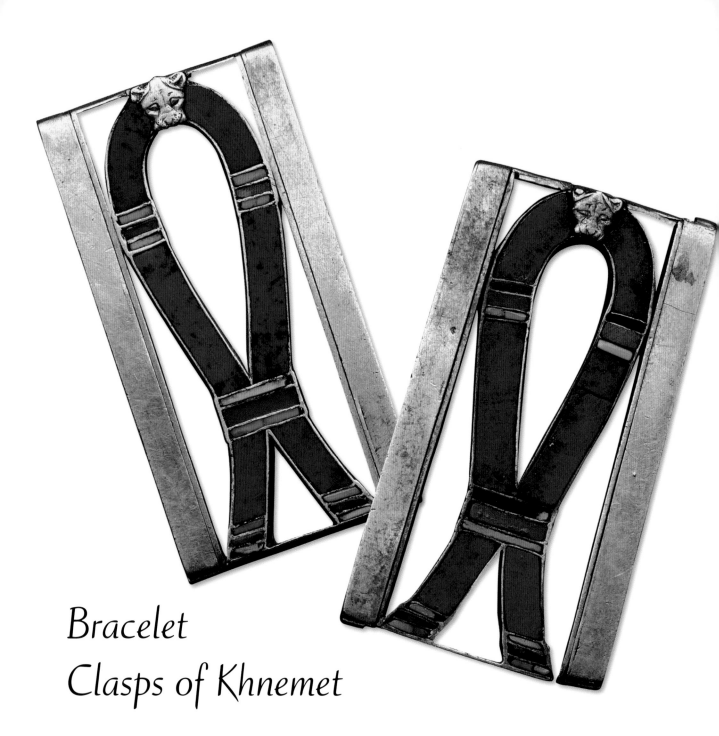

Bracelet
Clasps of Khnemet

Materials: Gold, lapis lazuli, carnelian, turquoise
Dimensions: (h) 3.9 cm (1.54"), (w) 2.1 cm (0.83"), (wt) 12.3 g (0.43 oz)
Current location: Egyptian Museum, Cairo
Original location: Double tomb of Princesses Khnemet and Ita, funerary complex of Amenemhat II, Dahshur

(excavated by de Morgan in 1894)
Dynasty: 12th, 1985–1795 BC, Middle Kingdom
Reign: Amenemhat II (1922–1878 BC), Senwosret II (1880–1874 BC)
Owner: Princess Khnemet, a daughter of Amenemhat II and probable wife of Senwosret II
Museum entry: JE 31091, CG52044, CG 52045

In their simple elegance, these two bracelet clasps provide yet more evidence of the supreme craftsmanship associated with Princess Khnemet's jewelry.

The clasps were originally part of a bracelet consisting of sixteen strung rows of carnelian, turquoise, lapis lazuli, and gold beads, fastened by sliding detachable gold pieces along tongues at each edge of the bracelet.

Each clasp is in the form of the *sa* amulet (a folded reed mat shelter meaning 'protection') that acted as an all-purpose symbol against malevolent forces. The *sa* sign as an amulet is curiously rare, and mostly appears in the Middle Kingdom. However, it is often seen carried by the very popular hippopotamus goddess Taweret and by her consort, the complex god Bes, who together were associated with protection of children, pregnancy, and childbirth.

A protective lion or leopard head lies at the top of the *sa* symbol.

The main part of the protective sign is made of lapis lazuli imported via trade routes, and probably through the city of Byblos, from distant Afghanistan. The ties that bind the reeds within the symbol are made of carnelian and turquoise.

These semi-precious stones were used in such a piece as much for the magical properties of their color as for their value.

The red and orange-red of carnelian, as we have seen, represented aspects such as lifeblood, power, vitality, and the sun; the green of some turquoise and other stones represented fertility, joy, and the annual rebirth of lush vegetation along the Nile Valley (and, by extension, the rebirth of the dead in the Otherworld); the dark blue of lapis lazuli represented the protective and all-encompassing night sky; and the light blue of some turquoise represented the primordial waters (from which the world arose at the creation) and the daytime sky.

Princess Ita's Dagger

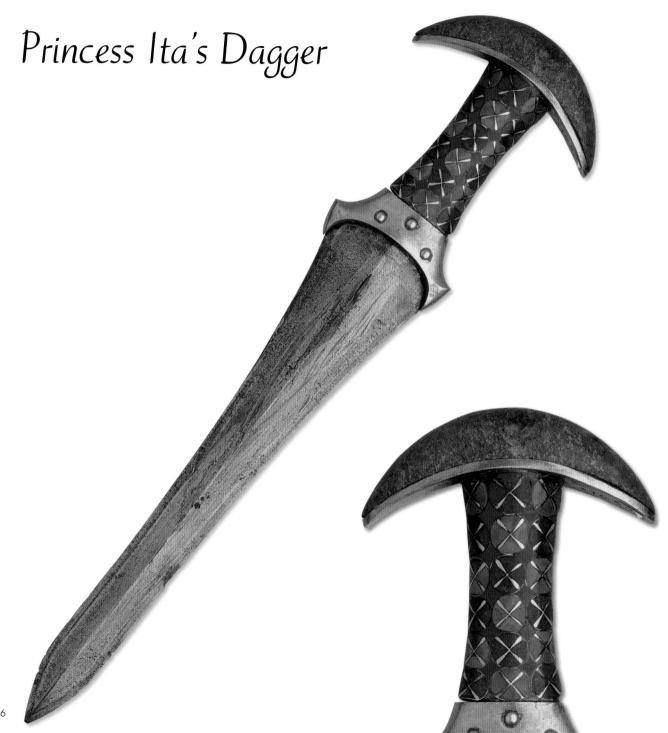

Materials: Gold, bronze, carnelian, turquoise, lapis lazuli, green feldspar.
Dimensions: (l) 26.8 cm (10.55″)
Current location: Egyptian Museum, Cairo
Original location: Double tomb of Princesses Khnemet of Princess Ita, funerary complex of Amenemhat II, Dahshur (excavated by de Morgan in 1894)
Dynasty: 12th, 1985–1795 BC, Middle Kingdom
Reign: Amenemhat II (1922–1878 BC)
Owner: Princess Ita, a daughter of Amenemhat II
Museum entry: JE 31069, CG 52982

Princess Khnemit shared a tomb in the funerary complex of their father Amenemhat II at Dahshur with Princess Ita. Although in both cases the mummies had been poorly prepared, by luck, the tombs had remained undisturbed through the centuries, and the grave goods remained intact.

As is true of most of the pieces discussed in this book, the strings of Princess Ita's jewelry had disappeared long ago, leaving archaeologists and conservators with the mystery of how they would have originally looked. Frequently, some pieces of the puzzle are left over.

However, this magnificent ceremonial dagger—found in a leather sheath—was one of the complete items found in Princess Ita's tomb, and in contrast to the openwork of much of Khnemet's jewelry, the impression is of a continuous, smooth, multi-colored surface of small cloisons (in which the semi-precious stones are separated by soldered gold wires) around a gold tube.

The crescent-moon-shaped pommel is made of a single large piece of lapis lazuli with gold on the underside. The shape of the pommel is unusual in an Egyptian context, and suggests—as does some of Khnemet's jewelry— influences or craftsmen from Syria or, perhaps, even further east.

The bronze blade—too weak to allow the use of the dagger as a weapon—is attached to the hilt by three gold pins.

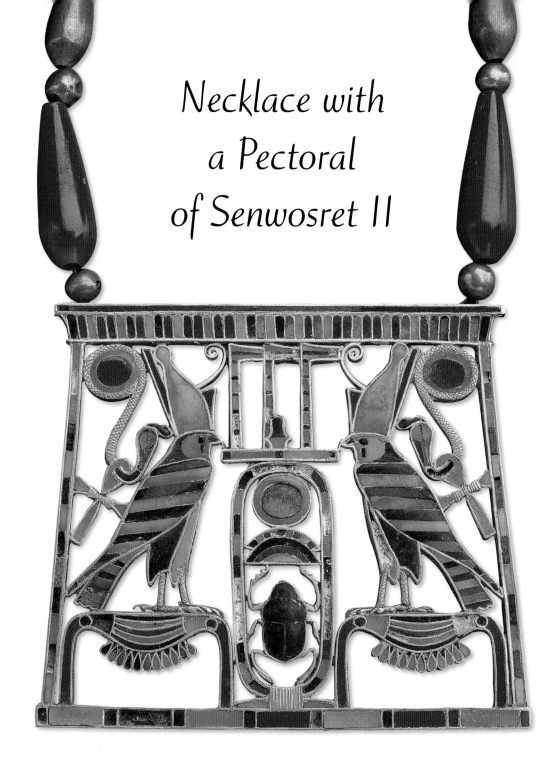

Necklace with
a Pectoral
of Senwosret II

Materials: Gold, carnelian, turquoise, lapis lazuli
Dimensions: (h) 4.8 cm (1.89"), (w) 5.6 cm (2.21"),
(wt) 37 g (1.31 oz)
Current location: Egyptian Museum, Cairo
Original location: Tomb of Princess Sithathor, funerary complex
of Senwosret III, Dahshur (excavated by de Morgan in 1894)
Dynasty: 12th, 1985–1795 BC, Middle Kingdom
Reign: Senwosret II (1880–1874 BC), Senwosret III (1874–1855 BC)
Owner: Princess Sithathor, probably a daughter of Senwosret III
Museum entry: JE 30857, CG 52001

Pectorals (chest ornaments) of this type, containing the names of the pharaoh, seem to have been given as royal gifts to family members during the Twelfth Dynasty—a practice which appears to have begun with Senwosret II and ended with Amenemhat III (1855–1808 BC).

This beautiful piece was found in the tomb of Princess Sithathor, a daughter of Senwosret III. Perhaps this was an heirloom inherited from her grandfather, although such heirlooms are rare.

These pectorals share a common theme—the protection of the Egyptian world by the king.

The frame takes the form of a kiosk with an ornamental molding, and is reminiscent of a temple gate (pylon) like those that can be seen today at Luxor or Karnak.

The name of Senwosret II appears at the center within a cartouche. Above this appear hieroglyphs meaning 'the gods are content,' another name used by Senwosret II after he came to the throne. The names of the king are protected on either side by a lovely and intricate representation of the falcon god Horus picked out in turquoise, lapis lazuli, and carnelian. Horus wears the double crown of Egypt—the red crown (deshret) of Lower Egypt and the white crown (hedjet) of Upper Egypt—and in both cases stands on the hieroglyph for gold (nebu), a divine and indestructible metal. The combination refers to another title by which the king was known—the 'Horus-of-Gold' name. This implied that the wearer was superior to all his enemies, as, in myth, the god Horus had been. In addition, the symbol had associations with the king's eternal presence as a royal descendant of Horus.

Behind each of the Horus figures is a sun disk around which the royal symbol of a rearing cobra (uraeus) is wound. An ankh life sign hangs from each of the cobras' necks.

Bracelets
of Queen Weret

Jewelry belonging to Queen Khenemetneferhedjet II—a wife of Senwosret III—was found as recently as 1994 in an opening in the east wall of the shaft that led to her burial complex. All the strings had decayed, leaving a collection of 6,500 beads and fifty decorative elements, from which the pieces on the following pages were among those reconstructed.

Despite their small size, the two lions modeled on these bracelets—lying on a small gold base plate—are exquisite in their detail. They are not sleeping, but fully alert and protective. However, their faces are relaxed and friendly rather than threatening (they also have slightly different expressions). The fur of their manes, their whiskers and claws, and even their muscles are all carefully engraved on the surface.

Although similar lion amulets from Dahshur were arranged in pairs facing each other, the presence of two sets of clasps suggests that only one lion appeared on each of these bracelets.

The strings consist of a repeating pattern of gold, turquoise, carnelian, and lapis lazuli beads ending in hollow reef-knot clasps fastened by a tongue and groove.

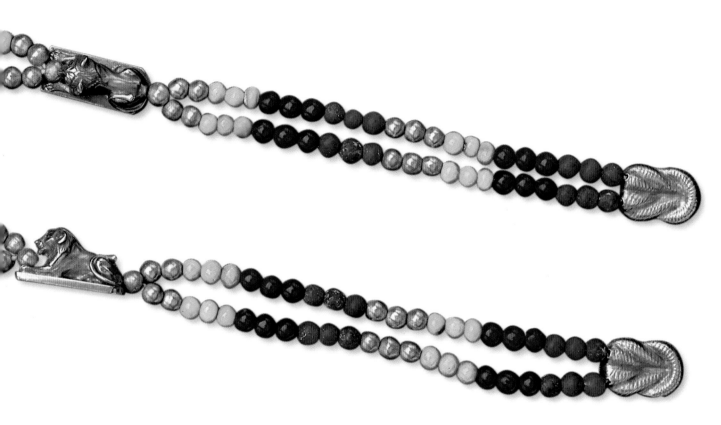

Materials: Gold, turquoise, lapis lazuli, carnelian, amethyst, Egyptian faience

Dimensions: Bracelet — (l) 15.5 cm (6.10"); clasp — (h) 4 cm (1.58")

Current location: Grand Egyptian Museum, Cairo

Original location: Pyramid IX, funerary complex of Senwosret III, Dahshur (excavated by Arnold in 1994–95)

Dynasty: 12th, 1985–1795 BC, Middle Kingdom

Reign: Amenemhat II (1922–1878 BC), Senwosret III (1874–1855 BC)

Owner: Queen Khenemetneferhedjet Weret II ('Weret'), wife of Senwosret III

Museum entry: JE 98786a–b, JE 98781a–b, JE 98790b, JE 98791b, JE 98792b, JE 98793b

Cowrie
Shell Belt

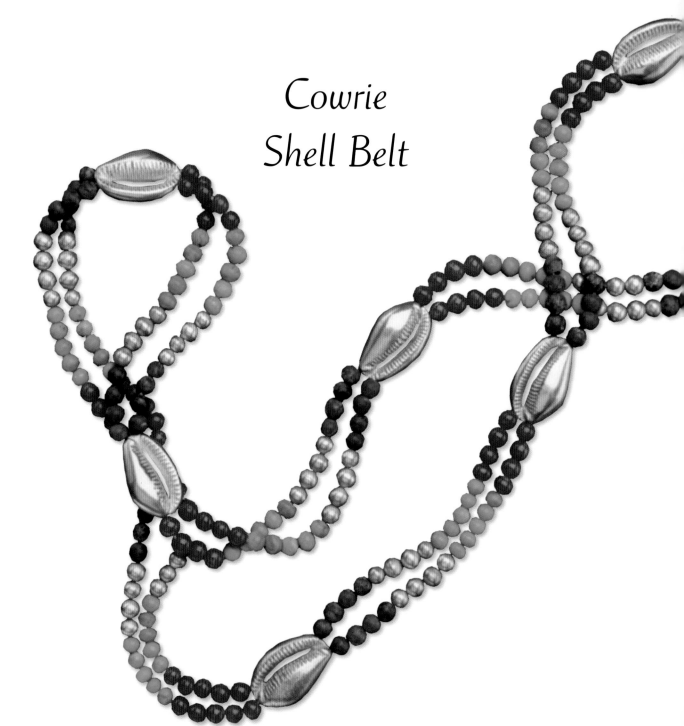

Materials: Gold, turquoise, lapis lazuli, carnelian
Dimensions: (l) 84 cm (33.07")
Current location: Grand Egyptian Museum, Cairo
Original location: Pyramid IX, funerary complex of Senwosret III,
Dahshur (excavated by Arnold in 1994–95)
Dynasty: 12th, 1985–1795 BC, Middle Kingdom
Reign: Amenemhat II (1922–1878 BC), Senwosret III (1874–1855 BC)
Owner: Queen Khenemetneferhedjet Weret II ('Weret'),
wife of Senwosret III
Museum entry: JE 98787, JE 98790a, JE 98791a, JE 98792a,
JE 98793a

The belt is composed of seven cowrie shell amulets and strung with repeating sequences of gold, carnelian, turquoise, and lapis lazuli beads.

As an amulet, the cowrie shell has a long history due to the resemblance of the shell to the female genitalia. Actual cowrie shells appear in burials in the Predynastic Period, but already by the Sixth Dynasty (2345–2181 BC) they also appeared in Egyptian faience, carnelian, and quartz.

As they were worn low on the hips, it is reasonable to assume that the purpose of these belts was both erotic and as a magical aid to, or demonstration of, fertility. The suggestion has been made that they may also have served a protective function in pregnancy.

The amulets are hollow and made of two parts created in a mold and soldered together. In other examples of the same type, though not in this piece, small stones or pellets were inserted in the shells that would have made a tinkling sound when the wearer walked or, more probably, danced. This suggests that, among the royal princesses who possessed such a girdle, the purpose may have been connected to a specific ritual—possibly associated with the goddess of femininity (among many other attributes) Hathor.

The girdle would normally be closed with a tongue-and-groove clasp, but none of the cowrie shells here serve this purpose. Perhaps the girdle was simply tied on, or perhaps a set of the reef-knot clasps associated with the bracelets discussed on the previous pages actually served this purpose.

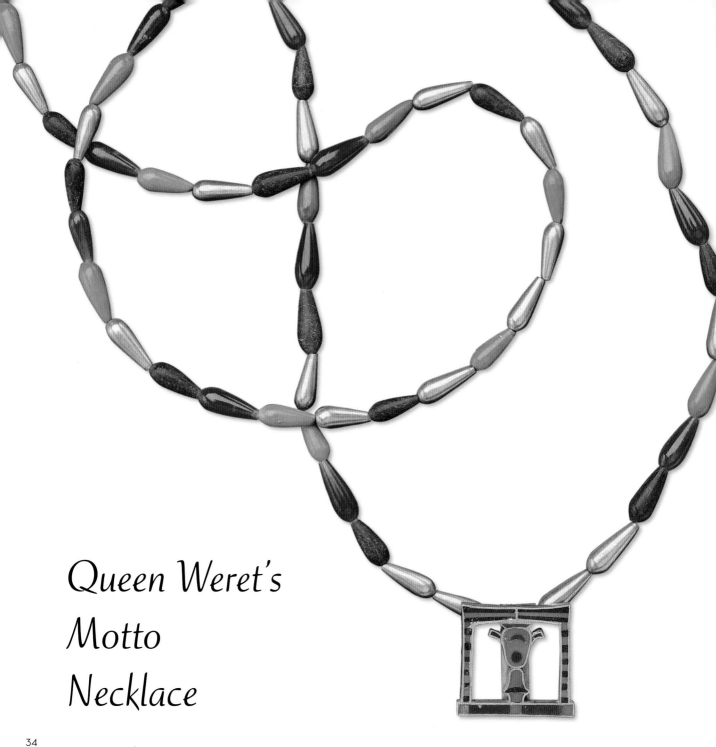

Queen Weret's Motto Necklace

Materials: Gold, turquoise, lapis lazuli, carnelian
Dimensions: Belt — 62.9 cm (24.76"); pectoral —
(h) 1.66 cm (0.65"), (w) 1.62 cm (0.64")
Current location: Egyptian Museum, Cairo
Original location: Pyramid IX, funerary complex of Senwosret III,
Dahshur (excavated by the Metropolitan Museum of Art in 1994–95)
Dynasty: 12th, 1985–1795 BC, Middle Kingdom
Reign: Amenemhat II (1922–1878 BC), Senwosret III (1874–1855 BC)
Owner: Queen Khenemetneferhedjet Weret II ('Weret'),
wife of Senwosret III
Museum entry: JE 98783, JE 98790c, JE 98971c, JE 98792c,
JE 98793c

The extraordinarily delicate clasp of this necklace is a magnificent example of the ancient Egyptian craftsmen's art and ingenuity.

The square ornament is composed of four hieroglyphs. The top and sides consist of two inward-facing netjer god signs (a square-ended flag wrapped around a pole and caught by the wind). These are inlaid with narrow strips of lapis lazuli and turquoise in the flag, and by squares of the same stones in the poles.

At the bottom is a *hetep* offering table, signifying 'peace,' made of turquoise and with two strips of carnelian at the bottom, rising up in two pieces of turquoise separated by a small crescent-shaped piece of lapis lazuli. In the remaining space lies an *ib* 'heart' sign of carnelian with projections of lapis lazuli. The center of the *ib* sign contains an oval of turquoise into which a minute crescent and circle of carnelian have been set. Remarkably, as it would not normally be seen, the rear of the piece is engraved (or 'chased') in minute detail with the same patterns.

The whole motto reads, 'the heart of the two gods is content.' The two gods referred to are the great enemies of ancient Egyptian mythology, the falcon god Horus and the god of chaos Seth. In one version of the epic, the opposing gods are eventually reconciled and their aspects and lands are united—Horus's domain was Upper Egypt (and the fertile Nile Valley) and Seth's the lands of Lower Egypt (and the desert lands to either side of the river).

The motto bracelet, which is similar to others found among the princesses' possessions, is thus a statement of the unity of the whole land of Egypt.

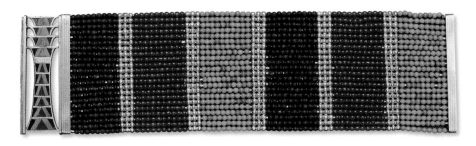

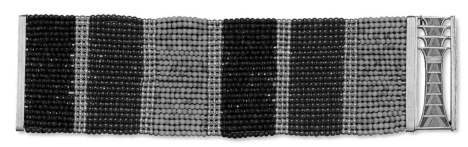

A Queen's Bracelets and Anklets

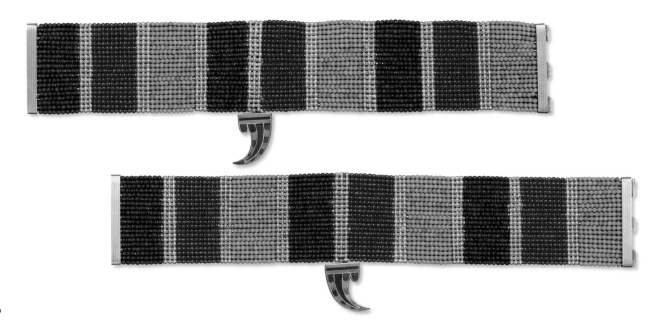

Materials: Gold, turquoise, carnelian, lapis lazuli
Dimensions: Bracelets—(h) 4 cm (1.56"), (l) 15.5 cm (6.10");
anklets—(h) 3.8 cm (1.50"), (l) 21.5 cm (8.47")
Current location: Grand Egyptian Museum, Cairo
Original location: Pyramid IX, funerary complex of Senwosret III,
Dahshur (excavated by Arnold, 1994–95)
Dynasty: 12th, 1985–1795 BC, Middle Kingdom

Reign: Amenemhat II (1922–1878 BC), Senwosret III
(1874–1855 BC)
Owner: Queen Khenemetneferhedjet Weret II ('Weret'),
wife of Senwosret III
Museum entry: Bracelets: JE 98785a–b, JE 98788a–b, JE 98790d,
JE 98792d, JE 98793d; anklets: JE 98784a–b, JE 98789,
JE 98780a–b, JE 98790d, JE 98792d, JE 98793d

The *djed* pillar is an amulet of great antiquity in ancient Egypt and represents the concept of 'enduring' and 'stable.' It is composed of a broad shaft crossed at the top by four horizontal bars. It may have originally represented a tree trunk with lopped-off branches associated with the worship of gods in Memphis. It was later adopted as a symbol of the great god of death and resurrection Osiris, and thought to represent his spine.

The *djed*-pillar clasps of these broad-patterned bracelets of twenty strings of tiny beads found in the tomb of Queen Weret II are masterpieces of composition. Each layer of the pillar consists of a triangle of carnelian pointing upward and surrounded by small angled bars of turquoise. The small space at the sides is filled with minute triangles of lapis lazuli. At the narrow neck of the trunk are four chased horizontal gold bars that connect with the framing gold end-bars that lock by means of a tongue and groove. The gold spacer bars of the bracelet are formed of tiny barrel beads soldered together—three beads wide and twenty-two beads deep.

The two claw anklets are similarly constructed, but the amulet hangs from the bottom. The top of the claw is made of narrow strips of turquoise and carnelian. Long, curved pieces of carnelian form the body of the claw, with small pieces of lapis lazuli and turquoise to the sides. The tip of the claw is made of a tiny piece of lapis lazuli.

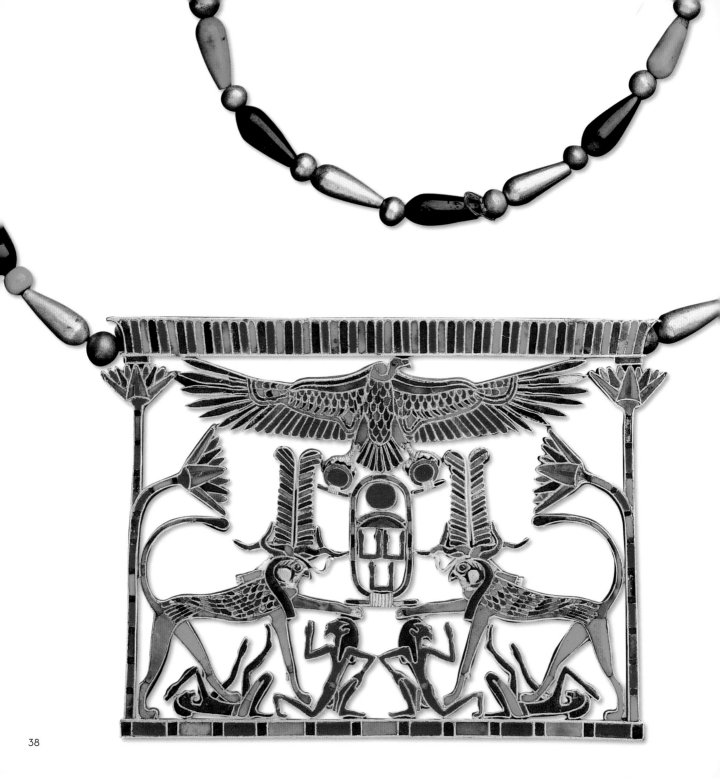

Pectoral
of Senwosret III

Materials: Gold, carnelian, turquoise, lapis lazuli, amethyst
Dimensions: (h) 6.1 cm (2.4"), (w) 8.5 cm (3.35"),
(wt) 61.9 g (2.18 oz)
Current location: Egyptian Museum, Cairo
Original location: Tomb of Princess Mereret, funerary complex
of Senwosret III, Dahshur (excavated by de Morgan in 1894)
Dynasty: 12th, 1985–1795 BC, Middle Kingdom
Reign: Senwosret III (1874–1855 BC)
Owner: Princess Mereret, daughter of Senwosret III
Museum entry: JE 30875, CG 52002

This pectoral was presumably a gift from Senwosret III to his daughter, Princess Mereret, who was buried within her father's funerary complex at Dahshur.

It takes the form of the now-familiar kiosk, with a molded cornice at the top, but in this piece the walls are two slender lotus flowers (with a second lotus flower flanking the stem and connecting with the interior elements). The floor of the kiosk is in the form of a mat composed of a pattern of blocks.

A central cartouche contains the name of Senwosret III, and this is flanked by two falcon-headed sphinxes ('hieracosphinxes'), representing the king himself, as he tramples on two of the traditional enemies of Egypt. One of the back paws of each sphinx presses down on a Nubian from the south, and a front paw rests on the head of a pleading Libyan tribesman from the west. On the heads of the sphinxes are tall plumes and rams' horns. The rams' horns are in both straight (representing an ancient breed within Egypt) and curved (representing a breed introduced during the Middle Kingdom) forms. The body of each sphinx is picked out in minute cloisons of gemstones and gold wire.

Above the whole scene flies a magnificently detailed representation of the vulture goddess Nekhbet, patron goddess of Upper Egypt and protector of the king—whom she shelters below her outstretched wings. In her talons she clutches extra protection in the form of the *shen* symbol.

The chain is composed of ball beads of gold and turquoise, alternating with drop beads of gold, turquoise, and lapis lazuli.

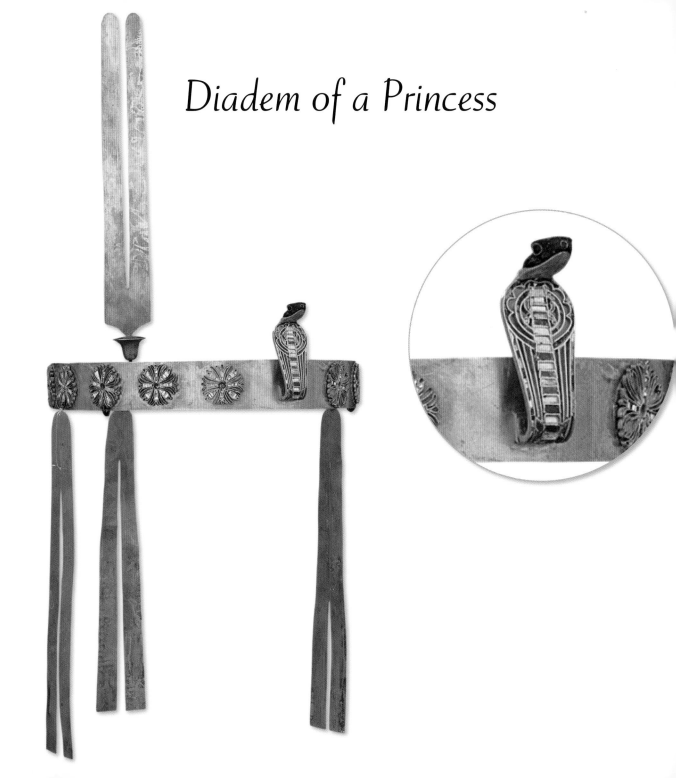

Diadem of a Princess

Materials: Gold, lapis lazuli, carnelian, green feldspar
Dimensions: (h) 44 cm (17.32"), (w) 19.2 cm (7.56"),
(d) 20 cm (7.87"), (wt) 280 g (9.88 oz)
Current location: Grand Egyptian Museum, Cairo
Original location: Tomb of Princess Sithathoriunet,
funerary complex of Senwosret II, Lahun
(excavated by Petrie in 1914)

Dynasty: 12th, 1985–1795 BC, Middle Kingdom
Reign: Senwosret II (1880–1874 BC), Senwosret III (1874–1855 BC),
and Amenemhat III (1855–1808 BC)
Owner: Princess Sithathoriunet, daughter of Senwosret II
and probable wife of Senwosret III. She was buried during the reign
of Amenemhat III.
Museum entry: JE 44919, CG 52641

This lovely diadem—probably intended to complement a wig used only on ceremonial occasions—was found at Lahun within the funerary complex of Sithathoriunet's father, Senwosret II, though it is probable that the princess was a wife of Senwosret III.

Ceremonial wigs and their ornaments might sit on the natural hair of the wearer, and, in this case, the wig of human or animal hair would probably comprise one piece with the ornaments.

The diadem consists of a plain gold band joined at the rear. At the front is a detachable rearing cobra uraeus, indicating the royal status of the wearer—with a lapis lazuli head, garnet eyes set in gold, and a hood of carnelian, turquoise, and lapis lazuli.

Around the band are fifteen inlaid rosettes of bud shapes between petals, alternating with seedpods or stamens. Both the pods and the petals are inlaid with Egyptian faience, and the petals are inlaid with carnelian.

Three hinged pairs of gold streamers fall from the band, and tubular gold beads threaded onto tresses would have completed the effect.

To the rear, two plumes stand up emerging from a papyrus bud. These plumes are similar to those found on the diadem of known priestesses of Hathor, leading to the suggestion that the princess—who shares part of her name with the goddess—was also one of her priestesses.

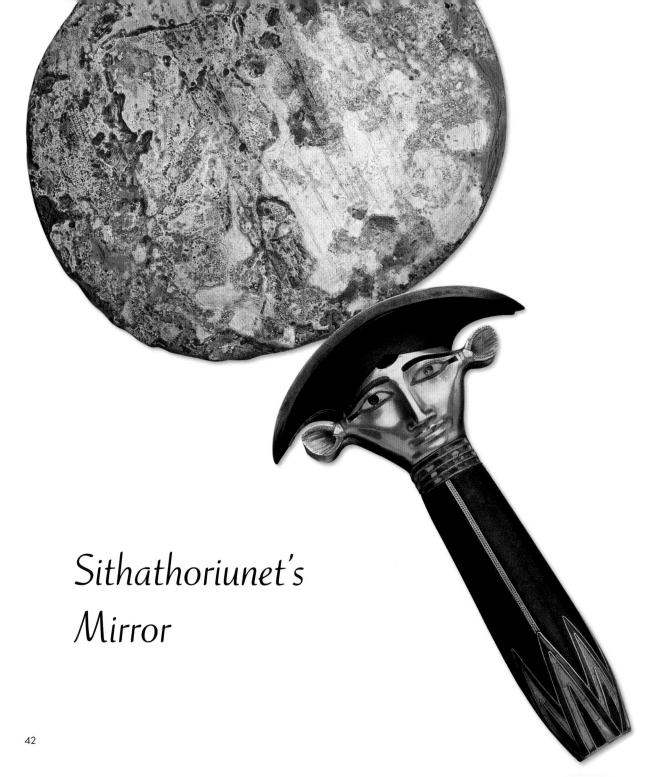

Sithathoriunet's
Mirror

Materials: Silver, gold, electrum (gold/silver alloy), obsidian, glass paste, semi-precious stones
Dimensions: (h) 28 cm (11.02"), (w) 15 cm (5.91"), (wt) 780 g (27.51 oz)
Current location: Grand Egyptian Museum, Cairo
Original location: Tomb of Princess Sithathoriunet, funerary complex of Senwosret II, Lahun (excavated by Petrie in 1914)

Dynasty: 12th, 1985–1795 BC, Middle Kingdom
Reign: Senwosret II (1880–1874 BC), Senwosret III (1874–1855 BC), Amenemhat III (1855–1808 BC)
Owner: Princess Sithathoriunet, daughter of Senwosret II and probable wife of Senwosret III. The princess was buried during the reign of Amenemhat III.
Museum entry: JE 44920, CG 52663

The full effect of jewelry and wig ornaments could be seen by Princess Sithathoriunet in this stunning mirror—the most beautiful to have been created by ancient Egyptian craftsmen.

Double-faced, the mirror takes the form of a papyrus stem crowned by the head of the goddess Hathor—more evidence of a close connection between the princess and the goddess.

One of the great goddesses of ancient Egypt, Hathor had many aspects, but essentially she was the goddess of femininity. In myth, she was the mother or wife of the god Horus and thus connected intimately to the kings of Egypt, who were his descendants on the throne.

She was also closely connected to the great sun god Re (as an 'eye of Re,' as his wife, or as his daughter), whose sun disk she often wears on her head. She might appear in human form, as a cow, or, as here, as a human face with cow's ears. Particularly in her cow form, she is often pictured emerging from papyrus reeds, which may explain the form of the mirror. The handle is made from obsidian—a volcanic glass that probably came from Ethiopia—and the lotus form at the bottom is composed of semi-precious stones and electrum (a gold/silver alloy which contained less than 75 percent gold).

The silver for the reflecting surface would probably have been an import from states to the northeast of Egypt. As we have noted, silver was highly prized. It was associated with the moon, and, as a divine metal, it was thought to form the bones of the gods in the same manner that gold formed their flesh.

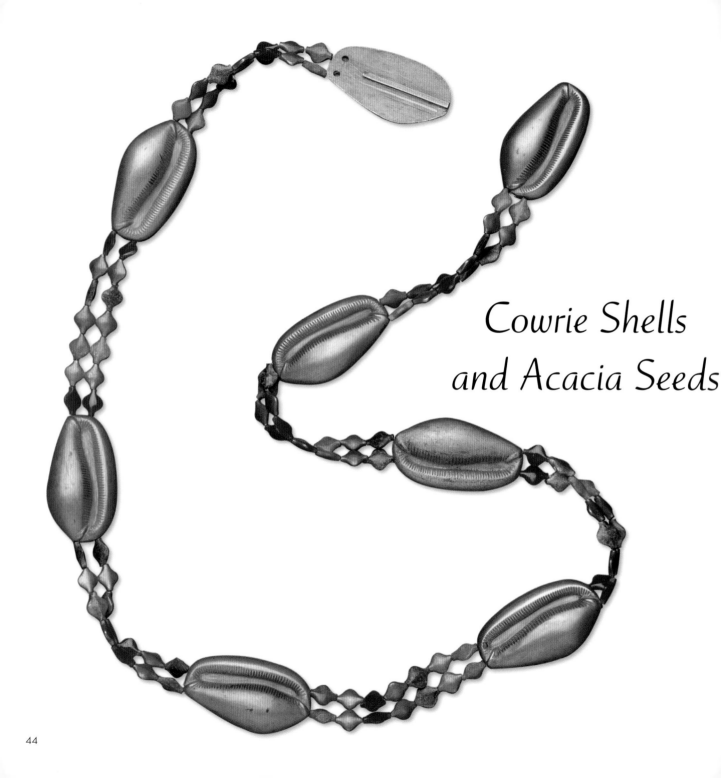

Cowrie Shells
and Acacia Seeds

Materials: Gold, lapis lazuli, carnelian, and green feldspar
Dimensions: Belt — (l) 70 cm (27.56"); cowrie shells —
(l) 3.8 cm (1.50"), (w) 2.1 cm (0.83"), (wt) 7 g (0.25 oz)
Current location: Egyptian Museum, Cairo
Original location: Tomb of Princess Sithathor, funerary complex
of Senwosret III, Dahshur (excavated by de Morgan in 1894)
Dynasty: 12th, 1985–1795 BC, Middle Kingdom
Reign: Senwosret III (1874–1855 BC)
Owner: Princess Sithathor, probably a daughter of Senwosret III
Museum entry: JE 30858, CG 53123, CG 53136

This cowrie shell amulet belt is similar to that of Queen Weret II, and presumably served the same purpose (the tongue-and-groove clasp mechanism can be seen clearly in this example).

Here, however, the belt is a masterpiece of the craft of the ancient Egyptian bead-maker (*iru weshbet*).

Each of the beads has been shaped to mimic the seeds of the acacia tree, and strung to resemble a double row of its distinctive pods.

Acacia seeds like these are occasionally also found as separate amulets. The abundant Nile acacia (or 'gum arabic') tree had a long association with Egyptian mythology, and its dried flowers were thought to have medicinal or magical properties. Parts of the tree were used to treat a diverse set of symptoms from diarrhea, colds, and coughs to sore gums, and as pain relief in labor.

Small raw gemstones would make their way to town workshops, from the inhospitable areas of the desert in which they were found, on the backs of men and donkeys (the donkey was first domesticated in Nubia or Egypt).

Once at the workshop, the beads were laboriously shaped by craftsmen using no abrasive harder than the hardest gemstone they had to hand.

The initial preparation of the stone involved chipping and grinding, but much of the finer work depended on the various forms of silica that Egypt possessed in abundance: chert or flint pieces formed drill bits to bore holes (copper or bronze wire and sand could be used to smooth and widen the holes); and sandstone, or sand itself, were used to grind and shape the bead. The polishing process required the finest sand paste applied with a cloth or leather.

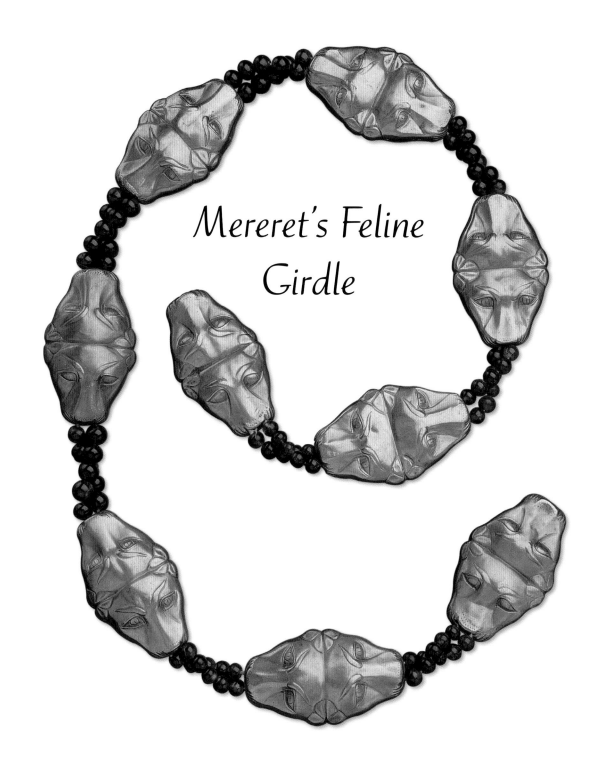

Mereret's Feline
Girdle

Materials: Gold, amethyst
Dimensions: Belt — (l) 60 cm (23.62"), (wt) 199 g (7.02 oz); amulets — 5.2 cm (2.05")
Current location: Egyptian Museum, Cairo
Original location: Tomb of Princess Mereret, funerary complex of Senwosret III, Dahshur (excavated by de Morgan in 1894)

Dynasty: 12th, 1985–1795 BC, Middle Kingdom
Reign: Senwosret III (1874–1855 BC) and Amenemhat III (1855–1808 BC)
Owner: Princess Mereret, daughter of Senwosret III
Approximate date: 1855–1808 BC
Museum entry: JE 30879, JE 30923, CG 53075

Cats, large and small, formed an important role in Egyptian jewelry and mythology. The ferocity and presence of the lion and the leopard were to be feared, but could also be harnessed magically, and the fertility of the cat was greatly admired.

A number of ancient goddesses were represented in the form of a lioness with a human body, and most were considered to fulfill—as a daughter of the sun god—the role of the vengeful and unpredictable 'eye of Re.'

The important and ancient goddess Sekhmet, however, combined this dangerous and destructive aspect with one of healing and protection.

In ancient Egyptian mythology, when Re became old on earth and his human subjects revolted against him, Sekhmet was sent to punish them and nearly brought about their destruction.

Later the plagues that afflicted ancient Egypt were thought to be the messengers or 'slaughterers' of Sekhmet.

Yet Sekhmet could also be called on to provide protection against disease and heal the sick. In addition, she was regarded as protecting the king in an almost motherly fashion.

This double feline amulet girdle with amethyst beads may represent a connection with one or more of these feline deities, or they may simply represent guardian lions or lionesses protecting the family of the king.

The suggestion has also been made that the intention of the makers of this lovely piece was to represent the enigmatic goddess of moisture Tefnut, and her consort, the god of air and sunlight Shu, who were sometimes represented as a pair of lions facing away from each other with the horizon and the rising sun between them.

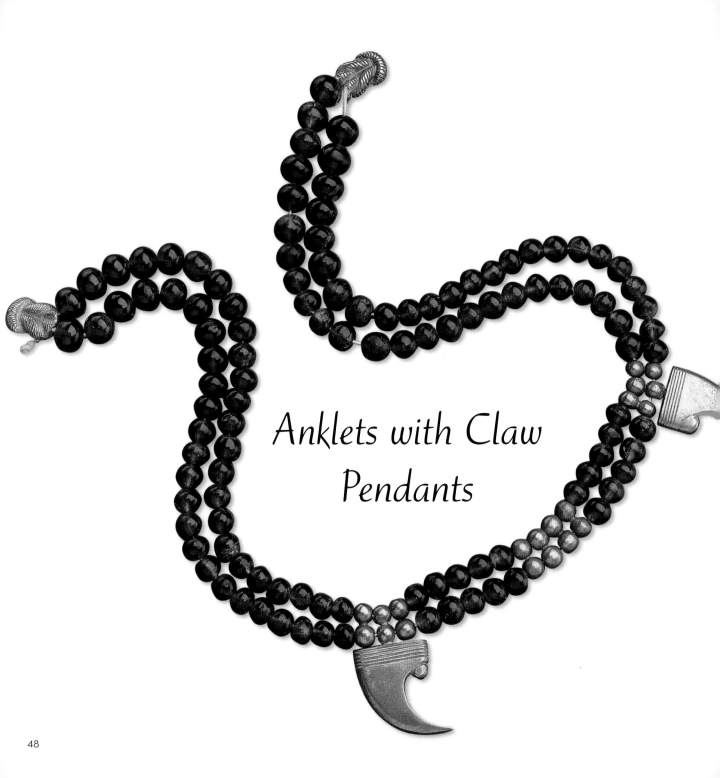

Anklets with Claw
Pendants

Materials: Gold, amethyst
Dimensions: Anklets — (l) 34 cm (13.39"); amulets —
(l) 2.9 cm (1.14"), (w) 0.4 cm (0.16"), (wt) 3.7 g (0.13 oz)
Current location: Egyptian Museum, Cairo
Original location: Tomb of Princess Mereret, funerary complex
of Senwosret III, Dahshur (excavated by de Morgan in 1894)
Dynasty: 12th, 1985–1795 BC, Middle Kingdom
Reign: Senwosret III (1874–1855 BC) and Amenemhat III
(1855–1808 BC)
Owner: Princess Mereret, daughter of Senwosret III
Museum entry: JE 30884a, JE 30923

Anklets were sometimes made to match bracelets, and it is probable that this piece was part of a set that included the girdle, described above, and lion amulet bracelets. It is likely that the whole ensemble was worn in some form of ritual involving dance, as can be seen in contemporary tomb paintings.

Ancient Egyptians used the same word (*menefret*) for both bracelets and anklets.

The latter were simply '(bracelets) for the legs' (*net redwy*), and were worn by both women and men (as were bracelets and collars).

This type of feline claw pendant anklet—strung together with amethyst beads and closed with a braided clasp—was worn by women only, however, presumably in relation to these unknown rituals. Although some of these amulets appear to have a feathered inlaid pattern on them (one appears in the jewelry of Princess Khnemet), suggesting that the claw may represent the talon of a bird of prey, the shape of the pendants here is clearly feline.

The leopard or lion claw amulet (which included, in the earliest times, real examples of such claws) can be found over the entire period of ancient Egyptian history from the Predynastic to the Roman Period. Yet they were particularly popular during the Middle Kingdom—all the queens and princesses mentioned in the preceding pages possessed amulets of this type.

Pendant of a Princess

Materials: Gold, carnelian, turquoise, lapis lazuli
Dimensions: (h) 4.6 cm (1.81"), (w) 4.6 cm (1.81"),
(wt) 23.65 g (0.83 oz)
Current location: Egyptian Museum, Cairo
Original location: Tomb of Princess Mereret, funerary complex
of Senwosret III, Dahshur (excavated by de Morgan in 1894)
Dynasty: 12th, 1985–1795 BC, Middle Kingdom
Reign: Senwosret III (1874–1855 BC) and Amenemhat III
(1855–1808 BC)
Owner: Princess Mereret, daughter of Senwosret III
Museum entry: JE 30877, CG 53070

Perhaps no object in this book says 'Ancient Egypt' more clearly than this lovely oyster shell pendant from the tomb of Princess Mereret.

The great British Egyptologist and art historian Cyril Aldred (1914–91) once said of it, "This is technically the supreme masterpiece from this period."

The pendant takes the form of a trimmed oyster shell, the center of which is made of a single piece of carnelian. The magnificent cloisonné-work design incorporates a lotus flower at the top, from which flows a wreath of stylized flower petals to either side.

At the bottom, the pendant is completed by three chevrons picked out in turquoise, carnelian, and lapis lazuli. The piece originally hung from a gold bead chain to which twenty-six small oyster shells were soldered at intervals.

Two other oyster pendants were found among the jewelry of princess Mereret, and others were found with Princess Khnemet and Princess Sithathor.

This is the finest example of the oyster shell amulet that was called in ancient Egyptian wedja—meaning 'healthy,' 'whole,' or 'sound.' It seems to have been worn mostly by women in order to absorb these specific characteristics.

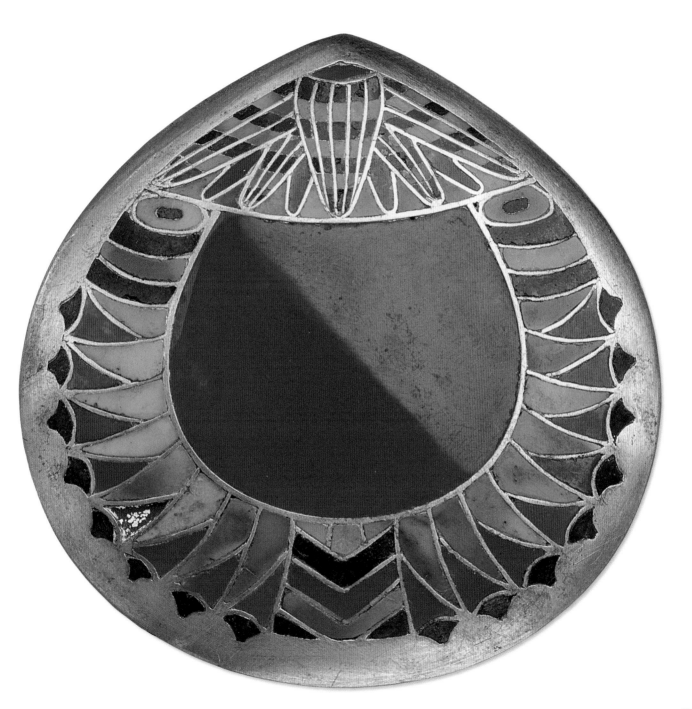

Neferuptah's Collar

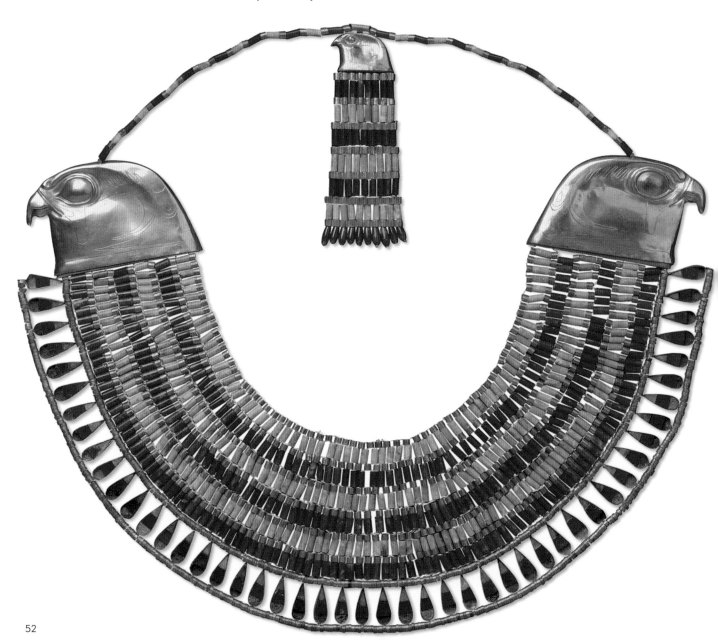

Materials: Gold, carnelian, feldspar, glass paste
Dimensions: (l) 36.8 cm (14.49"), (h) 10 cm (3.94")
Current location: Egyptian Museum, Cairo
Original location: Pyramid of Neferuptah, Hawara-South,
Fayum (excavated by Farag and Iskander in 1956)
Dynasty: 12th, 1985–1795 BC, Middle Kingdom
Reign: Amenemhat III (1855–1808 BC)
Owner: Princess Neferuptah, daughter of Amenemhat III
Museum entry: JE 90199

Princess Neferuptah may have been originally buried alongside her father Amenemhat III within his pyramid at Hawara, and then reburied in her own small, mudbrick pyramid about two kilometers to the southeast.

On her sarcophagus, she is described as 'a member of the elite, great one of the *hetes*-scepter [a symbol of royalty], great of honor, beloved king's daughter of his body.' On the sarcophagus, and on three silver vessels from the tomb, her name appears in a cartouche like that of a king, and it has been suggested that, in the absence of a son, Amenemhat intended Neferuptah to rule as a female king. It seems, however, that she predeceased her father—her sister, Sobekneferu (1799–1795 BC), eventually succeeding a few years after their father's death.

Among the items recovered from the burial was this magnificent broad collar (*wesekh*) that consists of three rows of blue-green feldspar and three rows of carnelian cylinder beads, separated by eight rows of small gold ring beads—all hung vertically. At the bottom is a fifteenth row of gold drops that are inlaid with carnelian, feldspar, and glass paste. The ends of the collar are formed by gold falcon-head terminals (or finials).

The matching counterpoise (*mankhet*) has another gold falcon's head, above three rows of carnelian and three rows of feldspar cylinder beads, separated by seven gold bead spacers. When the collar was worn the counterpoise would lie on the back between the shoulders, balancing the weight of the collar, and keeping it in place. Similar collars used solely for funerary purposes do not often have counterpoises, for obvious reasons.

Pectoral of Amenemhat III

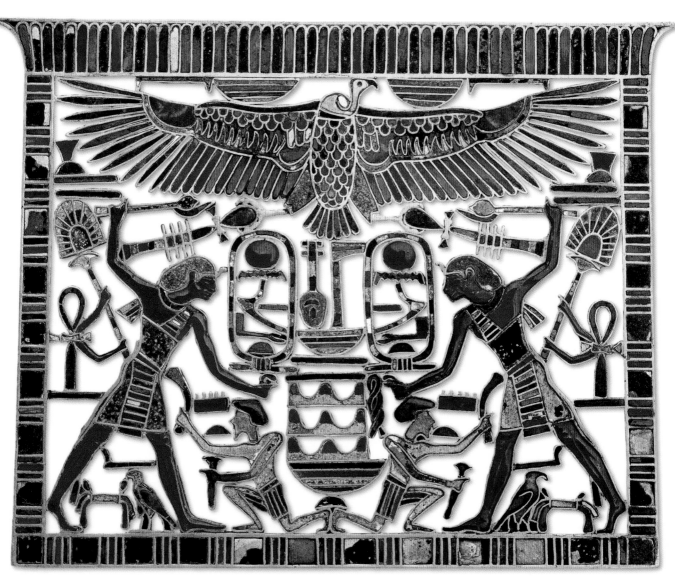

Materials: Gold, carnelian, turquoise, lapis lazuli,
Egyptian faience
Dimensions: (h) 7.9 cm (3.11"), (w) 10.4 cm (4.09"),
(wt) 132.1 g (4.66 oz)
Current location: Egyptian Museum, Cairo
Original location: Tomb of Princess Mereret, funerary complex
of Senwosret III (excavated by de Morgan in 1894)
Dynasty: 12th, 1985–1795 BC, Middle Kingdom
Reign: Senwosret III (1874–1855 BC) and Amenemhat III
(1855–1808 BC)
Owner: Princess Mereret, daughter of Senwosret III
Museum entry: JE 30876, CG 52003

The name of Amenemhat III appears in the cartouches at the center of this pectoral, and between the cartouches he is called 'good god, Lord of the Two Lands and Lord of all Foreign Lands.'

The king himself appears on either side in a stance familiar to anyone who has visited an ancient Egyptian temple, and which appears from the beginning of the history of Egypt. One of the king's hands, brandishing a mace, is raised as he prepares to smite the enemies of Egypt—in this case 'Asiatics' from the northeastern borders of Egypt. In his other hand, he holds the hair of an unfortunate tribesman who, pathetically, defends himself with a throwing stick and a dagger. The eastern origin of the tribes is described in hieroglyphs beside the submissive figures and between the legs of the king.

In the middle of his heroic action in defending Egypt, a living ankh sign is fanning the king.

Meanwhile, the wings of the vulture goddess Nekhbet stretch protectively across the whole scene at the top, and she is identified above her wings as 'Lady of Heaven' and below as 'Mistress of the Two Lands.' The goddess clutches a combined ankh and djed symbol above the head of the king.

Shortly after the death of Amenemhat III, the Twelfth Dynasty ended and Egypt descended into a long period of disarray characterized by a very long list of kings who mostly ruled for only a few years, and who seem to have seldom had extended family connections.

By around 1650 BC, at the end of the succeeding Thirteenth Dynasty (1795–1650 BC), Egypt had broken down into smaller political units. This disunity allowed a group of foreign princes of Palestinian origin (known as the Hyksos) to carve out a large part of northern Egypt for themselves centered on the city of Avaris within the Nile Delta. Thus began the period known to historians as the Second Intermediate Period (1650–1550 BC).

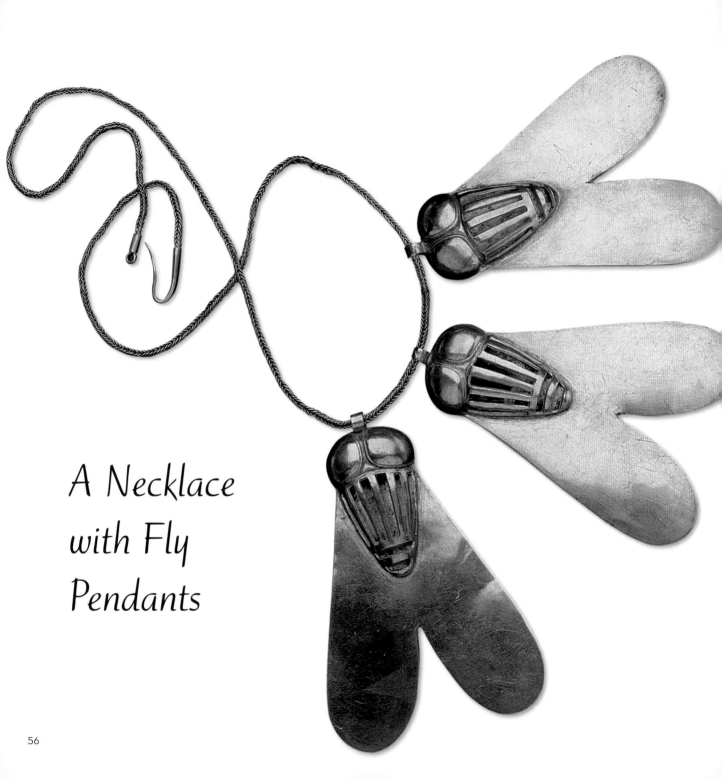

A Necklace
with Fly
Pendants

Materials: Gold, silver, bronze
Dimensions: Chain — (l) 59 cm (23.23"), (wt) 249 g (8.78 oz);
pendants — (l) 9 cm (3.54"), (w) 6.7 cm (2.64")
Current location: Luxor Museum, Luxor
Original location: Tomb of Queen Ahhotep, Dra Abu'l-Naga,
Thebes/Luxor (excavated by Mariette in 1859)

Dynasty: 18th, 1550–1295 BC, New Kingdom
Reign: Kings Taa (around 1560 BC), Kamose (1555–1550 BC),
and Ahmose I (1550–1525 BC)
Owner: Queen Ahhotep, wife of King Taa of Thebes and mother
of Ahmose I
Museum entry: JE 4694, CG 52671, Luxor J. 854

The damage inflicted on the psyche of the ancient Egyptians by the presence of the Hyksos in the north of the country is not easy to overestimate, and the kings of the rump state centered on Thebes (modern Luxor) dedicated themselves to removing them, while simultaneously defending themselves from a defiant Nubian state to the south.

The Hyksos were not going to go quietly, however, as can be seen from the injuries inflicted on the mummy of King Taa of Thebes, the husband of Queen Ahhotep. The Theban king Kamose (1555–1550 BC) succeeded in pushing the Hyksos further north, but also died young, and it was left to Ahmose I (1550–1525) to finally expel the Hyksos, when he was old enough to take command of the Egyptian army.

Ahmose I also regained lost territory in Nubia, thus establishing the foundations of the New Kingdom (1550–1069 BC).

An inscription at Karnak indicates that Queen Ahhotep greatly assisted her son by taking up arms herself, for which she may have been awarded this necklace of golden flies—a traditional reward for valor on the battlefield.

The wings of the flies are made from sheet gold upon which a second piece—hammered into a mold to represent the head and eyes—has been soldered. Slots were then cut along the back to represent the body of the fly. These are said to flash as the wearer moves, capturing the iridescence of the living insect.

The flies attach to the loop-in-loop chain by means of a small loop soldered between the eyes of each fly. The necklace closes by a clasp in the form of a simple hook and eye fastener.

Queen Ahhotep's Bracelet

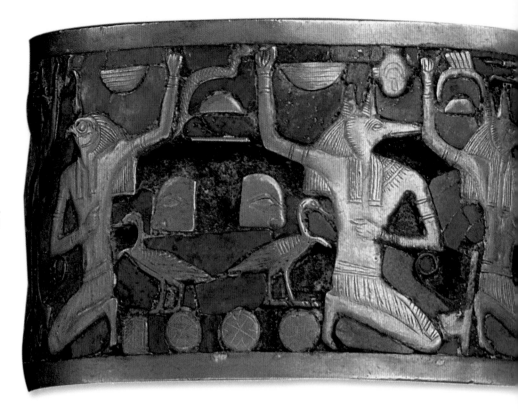

Although traditional in design, Ahhotep's jewelry also contained the earliest example of a new, rigid, hinged bracelet closed by two pins.

The bracelet is composed of two semicircular gold plates upon which the design elements in gold plate have been soldered. The background is made of lapis lazuli pieces applied with a black resin glue.

On the right hand side, the earth god Geb—wearing a short cloak and the crowns of Upper and Lower Egypt—

appears sitting on a throne. Before him kneels Ahmose I ready to be crowned by the god. The scene is repeated in reverse, separated by a fan resting on a *shen* sign. Ahmose is described as 'son of Re, of his body,' 'living like Re,' and 'good god, Lord of the Two Lands' along with his cartouche.

On the other side, in a reference that already stretched back deep into Egyptian history, the Souls of Pe (falcon-headed and representing the Lower Egyptian town of Buto in the Nile Delta) and Nekhen (jackal-headed and

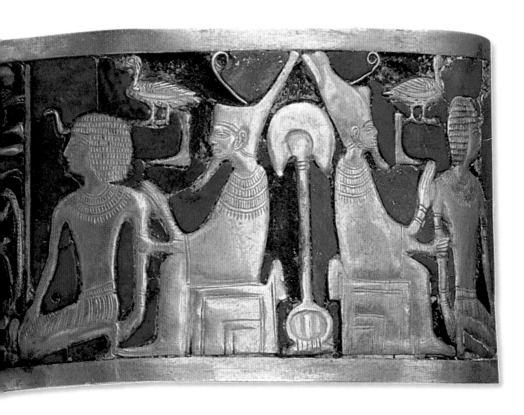

representing the Lower Egyptian town of the same name) kneel facing outward. Between the Pe figures lies the crown of Lower Egypt, and between the Nekhen figures lies the Double Crown of a united Egypt.

A *ba* bird symbol—representing the individual personality component of the soul—rests above the name of the towns. The inscription above says, 'They who are at the head of the Souls of Pe and Nekhen give all joy forever,' and 'they give all life and power forever.'

Materials: Gold, lapis lazuli
Dimensions: (h) 3.4 cm (1.34"), (d) 5.5 cm (2.17")
Current location: Egyptian Museum, Cairo
Original location: Tomb of Queen Ahhotep, Dra Abu'l Naga, Thebes/Luxor (excavated by Mariette in 1859)
Dynasty: 18th, 1550–1295 BC, New Kingdom
Reign: Kings Taa (around 1560 BC), Kamose (1555–1550 BC), and Ahmose I (1550–1525 BC)
Owner: Queen Ahhotep, wife of King Taa of Thebes and mother of Ahmose I
Museum entry: JE4684, CG 52069

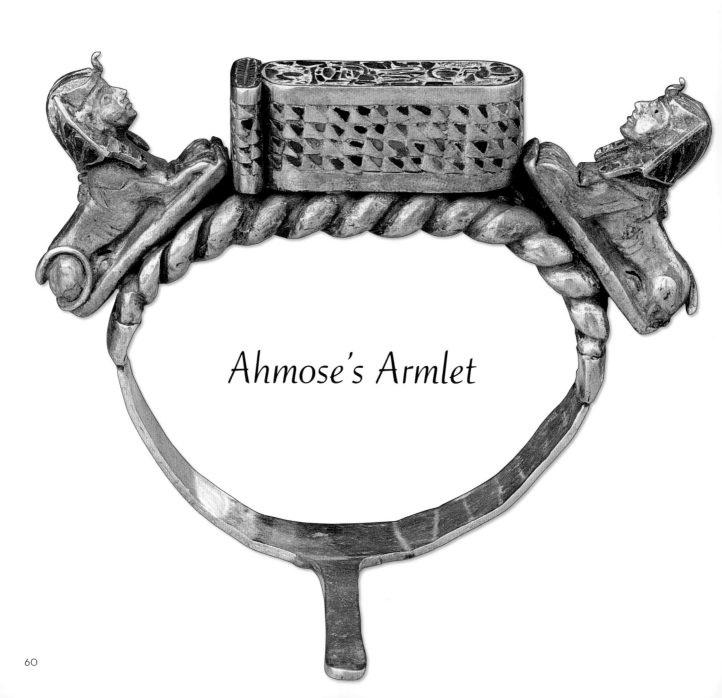

Ahmose's Armlet

Materials: Gold, carnelian, lapis lazuli, turquoise, green feldspar
Dimensions: (h) 8.2 cm (3.23"), (w) 11 cm (4.33"), 128 g (4.51 oz)
Current location: Egyptian Museum, Cairo
Original location: Tomb of Queen Ahhotep, Dra Abu'l Naga,
Thebes/Luxor (excavated by Mariette in 1859)
Dynasty: 18th, 1550–1295 BC, New Kingdom
Reign: Kings Taa (around 1560 BC), Kamose (1555–1550 BC),
and Ahmose I (1550–1525 BC)
Owner: Queen Ahhotep, wife of King Taa of Thebes and mother
of Ahmose I
Museum entry: JE4680, CG 19540

The story of the excavation of Queen Ahhotep's tomb is complicated, confusing, and unfortunate. The tomb is now unknown, and the mummy itself was stripped of its golden treasures and thrown away while the excavation director, Mariette, was away from the site in Cairo. In addition to Ahhotep's name, some of the items bore the name of King Kamose; many more carry Ahmose's titles. It is consequently not always clear what belonged to whom, but this armlet has a greater diameter than others in the collection, and may have belonged to King Ahmose himself.

Instead of being strung on a double cord, the armlet consists of a gold band, half of which has been flattened and the other (outward-facing) half of which has been molded around a core to resemble a double twisted cord.

The inner, flattened half is inlayed with *djed* and *tjet* (a protective 'knot of Isis') symbols, and has a tongue—with an inlaid feather design and chevrons at the top—that would have run down the center of the inside of the arm to keep the armlet in place.

On the outer side is a hollow cartouche box naming Ahmose and adding 'son of Re' and 'living forever' in sheet gold set in lapis lazuli. The sides are decorated with triangles inlaid with tiny pieces of lapis lazuli, carnelian, and turquoise.

To either side are sphinxes made of gold sheet soldered down the spine. Their striped *nemes* headdresses are inlaid with red and blue glass. The faces of the sphinxes are highly polished and the eyes are inlaid with glass or quartz with black glass pupils.

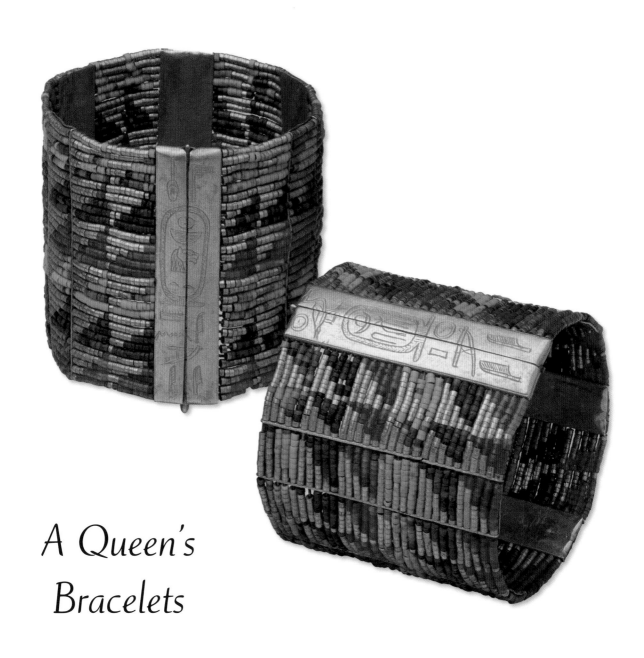

A Queen's
Bracelets

Materials: Gold, lapis lazuli, carnelian, turquoise
Dimensions: (h) 3.6 cm (1.42"), (d) 5.4 cm (2.13"),
(wt) 60 g (2.12 oz)
Current location: Egyptian Museum, Cairo
Original location: Tomb of Queen Ahhotep, Dra Abu'l Naga,
Thebes/Luxor (excavated by Mariette in 1859)

Dynasty: 18th, 1550–1295 BC, New Kingdom
Reign: Kings Taa (around 1560 BC), Kamose (1555–1550 BC),
and Ahmose I (1550–1525 BC)
Owner: Queen Ahhotep, wife of King Taa of Thebes and mother
of Ahmose I
Museum entry: JE 4686, JE 4687, CG 52071

The bracelets found with Queen Ahhotep are also of a novel construction in comparison to the Middle Kingdom examples we have seen earlier in this book.

The beads are strung on thirty gold wires, not threads, giving the bracelet greater rigidity, and the five gold spacers on the bracelet shown here have their two long sides turned up at right angles to accept the wires or allow them to pass through.

The gold end pieces of the bracelet also have aligning loops closed by passing a pin through them. The cartouches of Ahmose are composed of half the inscription on either end piece.

A similar bracelet was originally closed in the same manner, but at some time the bracelet was made larger by inserting a gold plate and a second pin that separates the inscription. A large spacer bar on the modified bracelet consists of an open gold box with gold hieroglyphs spelling out the name of Ahmose 'The good god, given life' against a lapis lazuli background.

Seven other thin spacer bars are simply made from gold beads soldered together. The carnelian and lapis lazuli beads are strung in eighteen rows and sections of a single color.

A diagonal motif appears on other jewelry from Queen Ahhotep's burial. Here it is composed of square groups of carnelian, lapis lazuli, and turquoise beads that are bisected—the remaining triangular area being filled with gold beads.

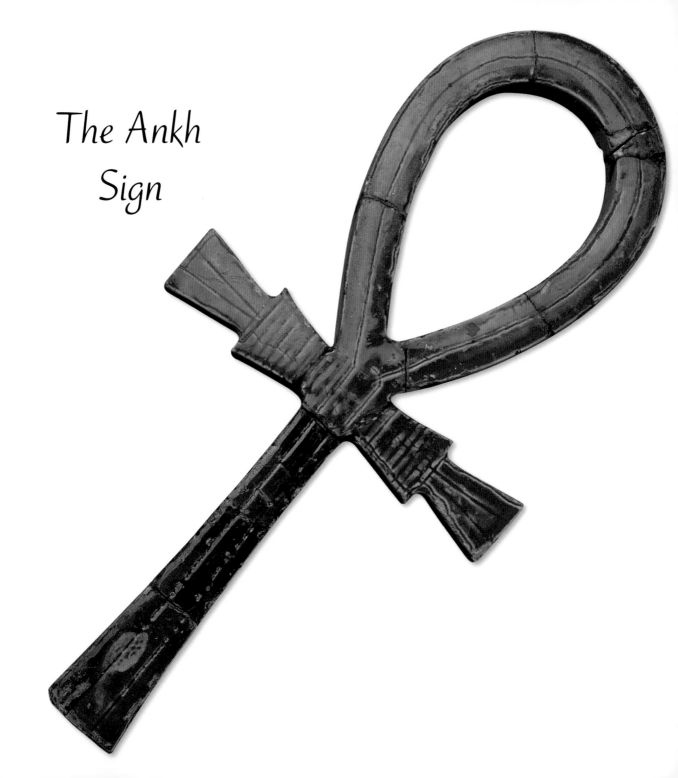

The Ankh
Sign

Materials: *Egyptian faience (glazed composition)*
Dimensions: *(h) 42 cm (16.54"), (w) 21 cm (8.27")*
Current location: *Egyptian Museum, Cairo*
Original location: *Tomb of Amenhotep II (KV 35),*
Valley of the Kings, Thebes/Luxor

(excavated by Loret in 1898)
Dynasty: *18th, 1550–1295 BC, New Kingdom*
Reign: *Amenhotep II (1427–1400 BC)*
Owner: *Amenhotep II*
Museum entry: *JE 32491-l, CG 24348*

Although the ankh hieroglyph, meaning 'life,' 'to live,' 'living,' and 'alive,' is the most familiar ancient Egyptian symbol today, and can often be seen in temple or tomb art being carried by gods and goddesses, offered to kings, or held by them, they are not common objects in the archaeological record. However, the ankh can often be found as part of amulets where it is combined with the *djed* and *was* symbols signifying together 'stability,' 'dominion,' and 'life.'

This fine example of an ankh on its own was found in nine pieces, and is lightly engraved on both sides.

The ankh may take its shape from a mirror, or the straps of a sandal. It may also originally have been a knot of cloth or reeds, the bars forming the ends of the material. In its earliest form, the ankh shared a resemblance with the tjet knot sign that symbolizes 'welfare' or 'protection.'

Twenty-two of these faience ankhs were found in the tomb of Amenhotep II (alongside thirty-nine wooden ankhs and thirty-six wooden *djed* pillars). Despite their presence in a king's tomb, the material from which they were made was not considered important with regard to their magical properties.

Egyptian faience (or, more properly, 'glazed composition') is simply a mixture of silica (crushed quartz or sand), soda (natron), and lime (from sand or crushed limestone), fired to produce a new material that imitates, at its surface, semi-precious stones (particularly blue and blue-green turquoise, green feldspar, or lapis lazuli).

A glaze including copper or Egyptian blue—and black manganese if design details or hieroglyphs were required—might be applied to a pre-molded core, or the color might be mixed into the whole object and molded before firing when a glaze would form on the outside, or the core might be placed in a powder of lime, ash, silica, charcoal, and color, which reacted and fused with the silica core during firing. The Egyptian name for the new material was *tjehenet*—'that which is brilliant' or 'dazzling.'

Faience was mostly used to produce small objects such as rings, amulets, and, above all, beads, but could also be used to make tiles and larger objects such as this.

A Glass Kohl
Holder

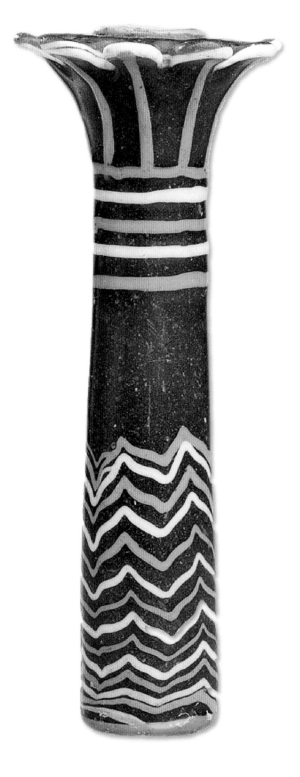

Materials: Polychrome glass
Dimensions: (h) 9.4 cm (3.70"), (d) 3.8 cm (1.50")
Current location: National Museum of Egyptian Civilization, Cairo
Original location: Possibly from Thebes/Luxor

(purchased by the Egyptian Museum in a lot in 1897).
Dynasty: 18th, 1550–1295 BC, New Kingdom
Reign: In or around the reign of Amenhotep III (1390–1352 BC)
Owner: Unknown
Museum entry: JE 31671, CG 44575

Polychrome glass holders such as this piece serve as a reminder that in addition to collars, bracelets, armlets, anklets, and other pieces of jewelry, cosmetics played an important part in the daily life of all ancient Egyptians. Cosmetics were valued for their magical medicinal properties in addition to their contribution to a youthful appearance.

Cheeks and lips might be colored red using iron oxide powder (derived from clay from Aswan and the desert oases) or a mixture of that powder and fat.

Ocher might also be used to treat eye problems, burns, and wounds.

More immediately distinctive in the context of ancient Egypt are green eye makeup (*udju*) derived from copper ore (malachite) from the Sinai Peninsula, and, particularly, black eyeliner (*mesdemet*) derived, usually, from lead sulphide (galena) and known by the Arabic word *kohl*.

An unadorned eye may have been regarded in ancient Egypt as 'unprotected,' and, among its magical or medical properties, kohl seem to have practically offered some protection from the intense light of the Egyptian sun,

acted as a deterrent to flies, and contained disinfectant properties. Kohl would have been mixed with oil in holders of various types, such as this, and applied with a short stick applicator—pointed at one end and round at the other—made of metal, stone, or wood.

Glass production was introduced to Egypt from the Near East during the New Kingdom, and the new material was used—like Egyptian faience—to produce objects that would often otherwise be made of more expensive materials. This kohl holder in the form of a palm tree imitates lapis lazuli and would have been formed around a core of clay, animal dung, and plant fiber that would have been removed after the firing process. The general shape and thickness of the piece would have been created by rolling the hot glass-covered core over a smooth stone slab. The yellow, white, and turquoise decoration was added by including thin strips of colored glass in the rolling process.

The leaves of the palm tree were created by drawing the top of the hot glass away from the core with pincers, and the wave patterns were created by drawing a blade down the glass.

A General's Earring

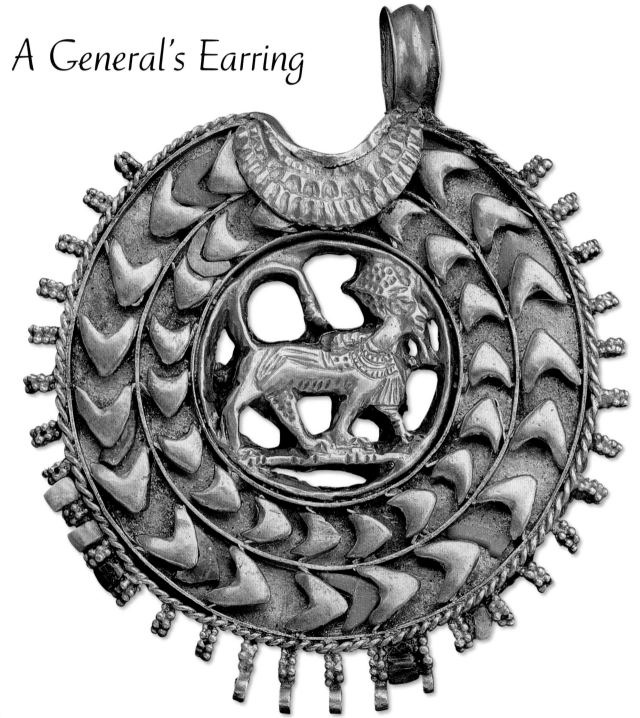

Materials: *Gold and glass paste*
Dimensions: *(d) 3.9 cm (1.54"), (wt) 17.8 g (0.63 oz)*
Current location: *Egyptian Museum, Cairo*
Original location: *Tomb of Horemheb, Saqqara*
(excavated by Martin in 1977)

Dynasty: *18th, 1550–1295 BC, New Kingdom*
Reign: *Amenhotep IV (Akhenaten; 1352–1336 BC),*
Tutankhamun (1336–1327 BC)
Owner: *General (later King) Horemheb (reigned 1323–1295 BC)*
Museum entry: *JE 97864*

Earrings (*shaqyu,* meaning simply 'rings,' to which had to be added, for clarification, 'for the ears') came into general use during the Second Intermediate Period and New Kingdom. They were worn first by women and later by men. By about 1400 BC, even the king had pierced ears (though he was not usually depicted wearing earrings, unlike queens).

There were multiple shapes of earring in use in ancient Egypt—including simple hoops, spirals, and barrel- and 'leech'-shaped types—but the most elaborate consisted of a stud-capped tube screwed through the earlobe into a second tube. From this would hang large elaborate ornaments—sometimes in the shape of birds with colored glass cloisonné wings, or in the form of cornflower pendants, for example.

The new decorative pieces of jewelry were highly valued, and in a scene from the unused tomb of Horemheb, the army commander under Tutankhamun and his successor Ay, the general can be seen being honored with presents of gold collars and large gold earrings. As luck would have it, the earring shown here was found in the same tomb as this scene. It was probably made during the last days of the reign of Tutankhamun's father (Akhenaten) or during the rule of the young king.

The earring is made of gold and fastened to the lobe by a screw that passed through two rings (one is now missing). A small gold leaf piece in the shape of a broad collar (*wesekh*) covers the join between the rings and the body of the earring.

Two circular bands decorated with a V-shaped design picked out in gold and blue glass surround the central image of the king as a sphinx wearing the blue 'war' crown (*khepresh*), with a rearing cobra *uraeus,* a broad collar, and the false beard of a king. Soldered gold-granule rings form a rim—the gap in between being filled with colored glass paste.

The five lowest protrusions from the earring probably served as attachments for pendants.

Pectoral of an Official

Hatiay was a senior official in the early years of the reign of Amenhotep IV (who became known later as Akhenaten). His title was 'overseer of the two granaries of Gempaaten'—the temple to the Aten built just outside the eastern precinct wall of Karnak Temple.

Although his tomb had been disturbed in antiquity, Hatiay's coffin, and those of three women also interred within the tomb, contained a large number of objects, including this rare gilded wood pectoral.

The necklace is strung with glass paste beads supporting the familiar kiosk- or temple pylon-shaped chest ornament.

The simple construction of this pectoral is symbolic of the hopes that all ancient Egyptians shared—not just kings, queens, princes, and princesses—concerning resurrection and passage to the Otherworld.

The pectoral contains a *djed* pillar (to the left) associated with the god Osiris and his resurrection. Although the *Book of the Dead* prescribed that such a *djed* pillar should be made of gold, here glass paste imitating turquoise and lapis lazuli—both colors associated with regeneration—is used. Carnelian, which also had a meaning associated with new life, completes the pillar.

To the right, a *tjet* symbol offers the protection of Isis (the consort of Osiris) to the deceased. This was expected be made of red jasper (the color of the goddess' blood), but here carnelian is used.

In the middle is a large scarab beetle made from amber.

The scarab amulet is the most numerous object to have survived from ancient Egypt. It first appeared in crude form in the Sixth Dynasty, and its inclusion on a pectoral such as this was a New Kingdom innovation.

Ever observant of nature, the Egyptians drew a parallel between the Egyptian scarab beetle's habit of rolling a large ball of nutritious animal dung to its nest with the long journey of the sun disk each day across the sky. Larvae of the beetle were also seen to emerge from a similar dung ball, so the scarab became associated with the emergence of new life, and, hence, resurrection. As a hieroglyph, the scarab (*kheper*) carries the meaning of 'to come into being' or 'to be created.' Only a few objects made of amber (hardened tree resin that is millions of years old) are known from ancient Egypt. It is possible that this amber came from the far-off Baltic coast—objects of what appears to be Baltic amber are known from this period in Greece and Crete. However, other sources of similar tree resins are known in East Africa, the Levant, and southern Europe.

Materials: Gilded wood, amber (tree resin), carnelian, lapis lazuli, glass paste

Dimensions: (h) 11 cm (4.33"), (w) 14.1 cm (5.55")

Current location: Egyptian Museum, Cairo

Original location: Tomb of Hatiay, Sheikh Abd el-Qurna, Luxor

(excavated by Daressy in 1896)

Dynasty: 18th, 1550–1295 BC, New Kingdom

Reign: Amenhotep IV (later Akhenaten; 1352–1336 BC)

Owner: Hatiay, overseer of the granaries of the temple of Aten at Karnak

Museum entry: JE 31379, CG 12196

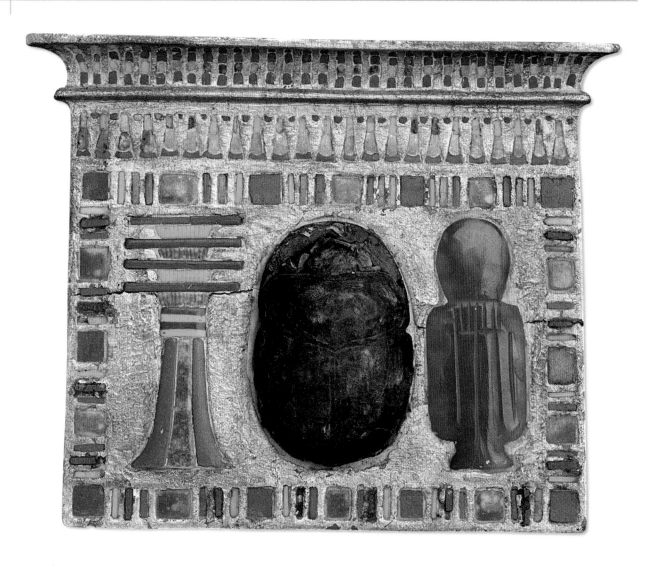

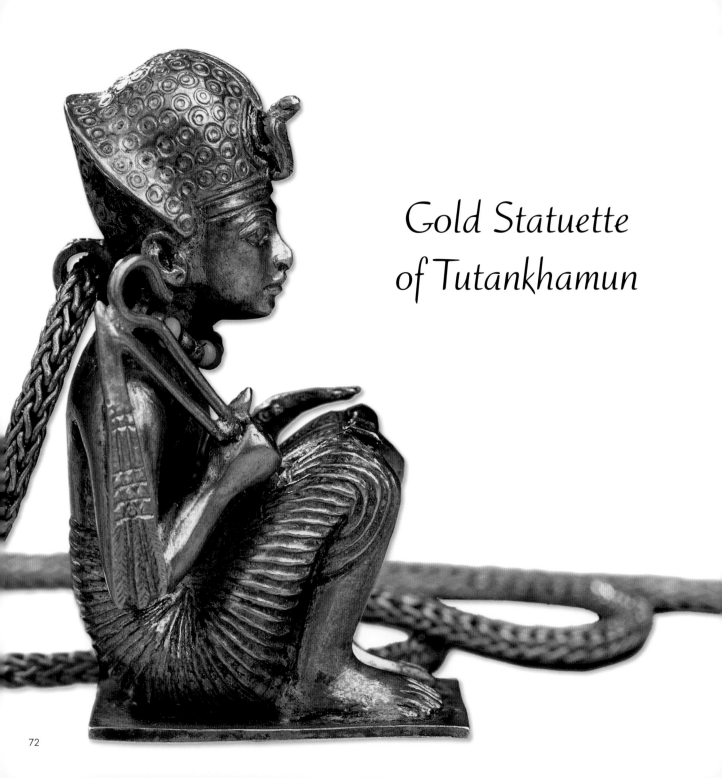

Gold Statuette
of Tutankhamun

Materials: Gold, glass paste
Dimensions: Chain — (l) 54 cm (21.26″), pendant —
(h) 5.4 cm (2.13″)
Current location: Grand Egyptian Museum, Cairo
Original location: Tomb of Tutankhamun (KV 62), Valley of the

Kings, Thebes/Luxor (excavated by Carter in 1922)
Dynasty: 18th, 1550–1295 BC, New Kingdom
Reign: Tutankhamun (1336–1327 BC)
Owner: King Tutankhamun, probable son of Akhenaten
Museum entry: JE 60702, Carter 320-c

The story of the last-minute discovery of the tomb of Tutankhamun in 1922 by the British archaeologist Howard Carter is well known. Although the tomb had been robbed at least twice soon after the young king's death, most of the contents were retrieved and replaced more or less where they had been originally placed. Shortly after the final sealing of the tomb, a flash flood brought tons of debris from higher up in the Valley of the Kings, and, by covering the entrance, preserved the tomb.

Tutankhamun came to the throne when he was about ten years old, and died at around the age of nineteen. His untimely death is a probable reason why many of the items in the tomb may have been made originally for deceased members of his family. That his family included the reviled figure of his father Akhenaten, and Tutankhamun was the last of that king's direct line to ascend the throne, may also account for the large number of items crowded into the tomb.

Although there are some doubts, it is difficult to believe that this lovely solid gold piece did not belong to Tutankhamun. The king is seen squatting, in the pose of child, wearing the *khepresh* war crown with a rearing cobra *uraeus* at the front. An argument for this being Tutankhamun, and not an earlier king such as his grandfather Amenhotep III, is that the ears of the tiny king are pierced.

The upper part of the body (apart from a tiny necklace of gold and glass beads), and the king's arms and legs, are bare, though he wears a kilt and apron. In his right hand, he carries the crook and flail regalia of the king, and his left hand rests on his knee.

The pose of the king as the newborn sun is reminiscent of representations of the sun god himself, squatting like a child on a lotus flower as he emerged at the creation in Egyptian mythology, in which he also carries a crook and flail in one hand.

Tutankhamun's Daggers

The ceremonial daggers found on the mummy of Tutankhamun are two of the finest decorative pieces to have survived from ancient Egypt.

One of the daggers has a blade of gold, the other, extraordinarily, has a blade of iron made from a meteor. The latter was probably imported or given as a gift from within the area bounded by modern Asiatic Turkey (Anatolia). Although iron ore could be found across Egypt, and was sometimes used in the making of small amulets, large artifacts made from iron were always imported. The continuing preference for copper alloy weapons, in particular, would come back to haunt the kings of Egypt in centuries to come.

On top of the pommel of the gold-bladed dagger, cloisonné lily petals surround the cartouches of the king. On the underside of the pommel are two falcons with *shen* ('eternity') signs in their talons.

The hilt of the dagger is decorated with alternating bands of gold granule geometric designs and lily petals in semi-precious stones. The middle, raised band is made up of tiny red and blue disks. At the base of the hilt is a band of spirals in a rope pattern made of gold wire.

In contrast, the blade is simple, with a plain horizontal band at the top, and a diamond and dot pattern below. Beneath this pattern are two lightly engraved lines, above an engraving of palm leaves and flowers. Two grooves descend to the bottom of the blade like stems.

One side of the sheath is covered by a feathered 'rishi' pattern of cloisonné semi-precious stones, relieved at the top by a flower petal frieze, and at the bottom by the head of a fennec or desert fox. On the other side is an extraordinary embossed scene below an inscription identifying Tutankhamun as 'The good god, possessor of a strong arm, given life,' and the loops in a petal design by which the sheath was attached to a belt.

The scene below consists of an ibex attached by a lion; a calf with a dog on its back which is biting the calf's tail; a leopard and a lion attacking an ibex; a dog biting a bull; and a calf (wisely) running away. Between the animals are stylized plants, and an elaborate plant design completes the base. This whole design is likely to have been influenced by artistic traditions from beyond the northeast borders of Egypt.

The iron-bladed dagger has a broadly similar design and a less complex 'feathered' and floral gold sheath. The pommel, however, is made of rock crystal.

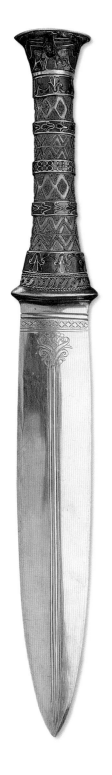

Materials: Gold, iron, glass, rock crystal, semi-precious stones

Dimensions: Upper dagger — (l) 34.2 cm (13.47"); lower dagger — 31.8 (12.52")

Current location: Grand Egyptian Museum, Cairo

Original location: Tomb of Tutankhamun (KV 62), Valley of the Kings, Thebes/Luxor (excavated by Carter in 1922)

Dynasty: 18th, 1550–1295 BC, New Kingdom

Reign: Tutankhamun (1336–1327 BC)

Owner: King Tutankhamun

Museum entry: JE 61585, JE 61584, Carter 256-c (a) & (b), Carter 256-dd 1&2

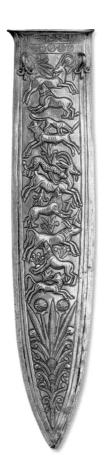

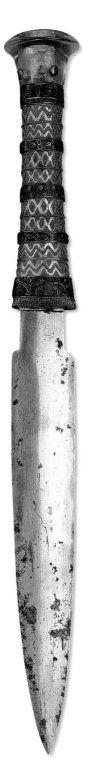

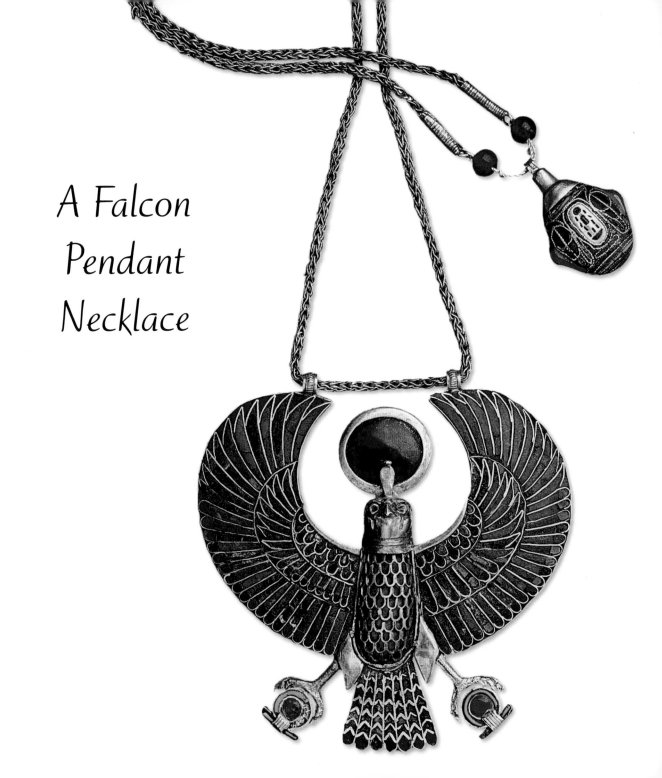

A Falcon
Pendant
Necklace

Materials: Gold, carnelian, chalcedony, semi-precious stone, glass paste
Dimensions: Chain—65 cm (25.59"); pendant—
(h) 8.5 cm (3.35"), (w) 9 cm (3.54")
Current location: Grand Egyptian Museum, Cairo
Original location: Tomb of Tutankhamun (KV 62), Valley of the

Kings, Thebes/Luxor (excavated by Carter in 1922)
Dynasty: 18th, 1550–1295 BC, New Kingdom
Reign: Tutankhamun (1336–1327 BC)
Owner: King Tutankhamun
Museum entry: JE 61891, Carter 256-uuu

Tutankhamun's father, Akhenaten, had suppressed the worship of Amun and his priesthood at Karnak in preference of the worship of the Aten sun disk—to which he had built great new temples in his new capital city of Akhetaten (modern Amarna).

When the nine- or ten-year-old boy, who had been born 'Tutankhaten,' ascended the throne a few years after the death of his father, the priesthood at Karnak reasserted itself. Atenism descended back into obscurity, and the city of Akhetaten was soon abandoned. Indeed, the argument has been made that Tutankhamun's tomb was more than usually richly endowed, for an otherwise relatively minor king, due to the gratitude of the restored priesthood across the Nile at Karnak.

This falcon pectoral—one of many from the tomb—was found on the mummy of the king. It represents a form of the complex falcon god Horus, who was deeply linked to kingship. The falcon's plain head is front-facing with the features finely engraved. A carnelian solar disk and rearing cobra *uraeus* of kingship rise above the head. The body is composed of a pale green stone enclosed in a gold mesh cage. The crescent-shaped wings are inlaid with carnelian and lapis lazuli. A *shen* sign of eternity is grasped in each of the talons.

At the other end of the gold chain is a counterpoise (*mankhet*) in the shape of an *ib* heart symbol made of chalcedony (*herset-hedj*, a blue-white form of quartz) decorated with gold granulation and glass paste. The cartouche of the king's coronation name lies in between rearing cobra *uraei*.

Ancient Egyptians considered the heart to be the most important organ in the body. They believed that it was where intelligence sat, where feelings and actions originated, and where memories were stored.

For this reason, in ancient Egyptian mythology, the passage of the deceased into the Otherworld would be determined by whether his or her heart balanced the feather of the goddess of truth and justice, Maat.

Necklace with
a Lunar Boat

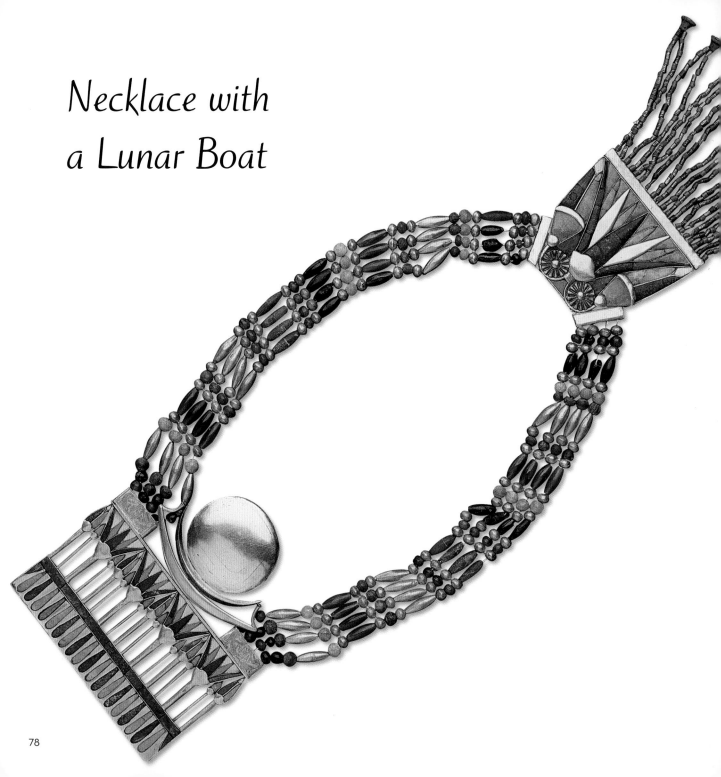

Materials: Gold, electrum, turquoise, lapis lazuli, carnelian, green feldspar, colored cement, polychrome glass
Dimensions: Necklace—(l) 23.5 cm (9.25"); pectoral—(h) 11.8 cm (4.65"), (w) 10.8 cm (4.25")
Current location: Grand Egyptian Museum, Cairo
Original location: Tomb of Tutankhamun (KV 62), Valley of the Kings, Thebes/Luxor (excavated by Carter in 1922)
Dynasty: 18th, 1550–1295 BC, New Kingdom
Reign: Tutankhamun (1336–1327 BC)
Owner: King Tutankhamun
Museum entry: JE 61897, Carter 269-k

The patterns of wear on many of the pieces from Tutankhamun's tomb, and their placement away from the mummy in boxes, suggest that the king wore them during his short life. Some of these, such as this piece, may have been worn during his coronation.

At the bottom of this pendant—found with other pieces in a cartouche-shaped box in the tomb's 'treasury'—is a long flat lapis lazuli symbol for 'sky' or 'heaven' (*pet*) above a gold plate inlaid with light and dark blue petals or dewdrops.

From the *pet* sign, lotus flowers and buds stretch upwards to a gold boat (or 'bark') that supports the crescent and full moon on its nightly journey across the heavens. As silver was associated with the moon, the two phases of the moon represented here are made of a silver/gold alloy (electrum).

To either side, box fittings incised with Tutankhamun's name attach the chest ornament to four strings of alternating round and barrel-shaped beads of gold (some soldered together to form spacers), lapis lazuli, turquoise, and carnelian.

The large gold counterpoise, or balancing weight, that lay at the back is inlaid with lotus blooms flanked by two buds with two rosettes above (when the necklace was worn).

The moon was associated with the god Khonsu, the mythological son of the great god Amun and his consort, the goddess Mut, who were venerated at Karnak. Khonsu is sometimes depicted with the crescent and full moon resting on his head. A statue of Khonsu wearing the sidelock of youth and with the face of Tutankhamun can be seen in the Egyptian Museum, Cairo.

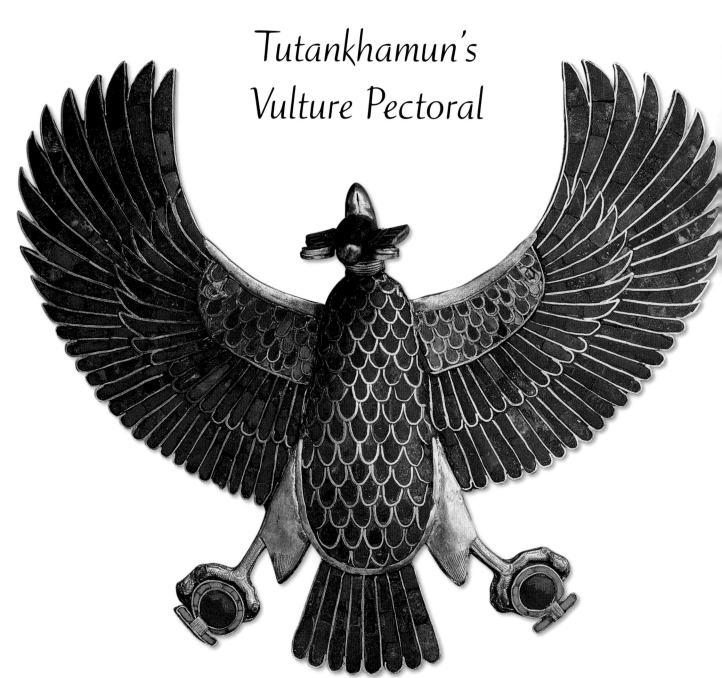

Tutankhamun's Vulture Pectoral

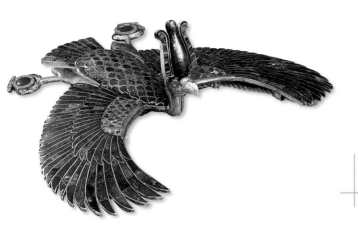

Materials: Gold, electrum, lapis lazuli, carnelian,
red and blue glass paste
Dimensions: (h) 14.1 cm (5.55"), (w) 16.4 cm (6.46")
Current location: Grand Egyptian Museum, Cairo
Original location: Tomb of Tutankhamun (KV 62),
Valley of the Kings, Thebes/Luxor (excavated by Carter, 1922)
Dynasty: 18th, 1550–1295 BC, New Kingdom
Reign: Tutankhamun (1336–1327 BC)
Owner: King Tutankhamun
Museum entry: JE 61894, Carter 267-i

This vulture pectoral was also found in a box within the treasury, and represents the goddess Nekhbet, the patroness of Upper Egypt. The pectoral is unusual in that, instead of showing the head of the vulture in conventional profile, the jeweler has chosen to have the goddess look up at the wearer—personally offering her protection. From practice drawings, and particularly from surviving wooden objects, we know that ancient Egyptian craftsmen were quite capable of artistic vision and innovation, but they were often limited by convention in tombs and temples.

Many of these conventions were greatly challenged during the reign of Akhenaten and his immediate successors (the Amarna Period), and that challenge continued in a more limited way after the collapse of Atenism and the full reinstatement of traditional religion.

The vulture's head and neck are cast in gold, and the head is topped with an electrum atef crown—the white crown of Upper Egypt (hedjet) with curled ostrich feathers each side, particularly associated with the god Osiris. The ostrich feathers are inlaid in red and blue glass.

The body of the vulture is only slightly curved and the tail is outspread. Both are made from fine cloisonné work including lapis lazuli, carnelian, and red and blue glass.

In her talons, Nehkbet holds the now familiar shen signs of eternal protection.

The back is engraved with the same design and is fitted with rings for the suspension cord that ends in tassels.

Nekhbet's counterpart, the cobra goddess Wadjet of Lower Egypt, was also often represented in Tutankhamun's tomb in the form of rearing cobras (as in the uraeus that is always depicted as resting on the brow of the king) and in the form of winged cobra sheet-gold pectorals.

Pectoral of Nut

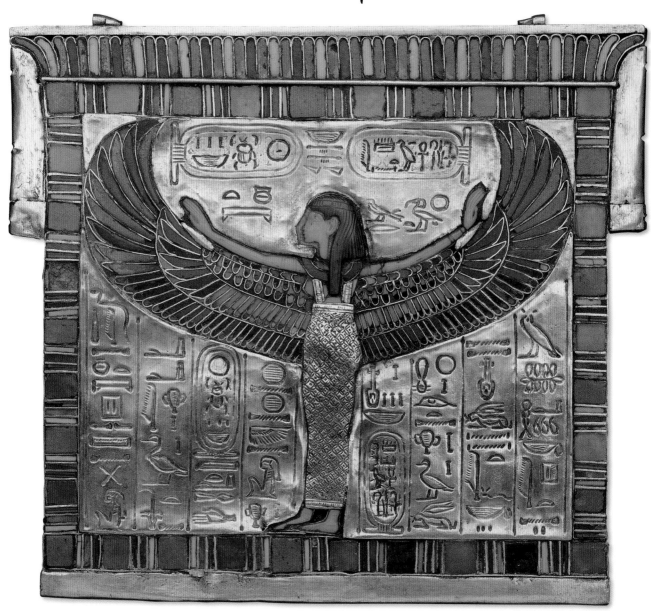

Materials: Gold, carnelian, red, light blue, and dark blue glass,
red cement
Dimensions: (h) 12.6 cm (4.96"); (w) 14.3 cm (5.63")
Current location: Grand Egyptian Museum, Cairo
Original location: Tomb of Tutankhamun (KV 62), Valley of the

Kings, Thebes/Luxor (excavated by Carter in 1922)
Dynasty: 18th, 1550–1295 BC, New Kingdom
Reign: Tutankhamun (1336–1327 BC)
Owner: King Tutankhamun
Museum entry: JE 61944, Carter 261-p (1)

Eight specifically funerary pectorals—without necklaces
or counterpoises—were also found some distance from the
mummy of the king. This simple pectoral of the goddess
Nut was found in the pylon-shaped shrine which lay
beneath a representation of the jackal- or dog-headed
god Anubis.

The kiosk is of a simple block design of carnelian and
glass paste, above which there is a palm frond cornice. It is
possible that this sheet gold piece was intended to be worn
as a belt buckle rather than a pectoral, as the attachments
are at the side and might have accepted four strings
of beads.

Beneath the cornice and top of the frame lie the
cartouches of Tutankhamun, protected by the wings of the
central figure. It has been suggested that the piece was
originally made for his father Akhenaten, as the cartouches
appear to have been altered to incorporate his son's names.

With her wings spread protectively, the sky goddess Nut,
described as the 'Great Spirit,' stands at the center.

She wears an intricately engraved shift dress, her wings are
feathered, and her face, spread arms, and feet are picked
out in light blue glass.

Below her outstretched wings, the text says that the
goddess 'opens her arms over her son (the king), in
protection of his body.' (In just such a protective role, Nut
would often be depicted on the whole length of the inside
of an ancient Egyptian coffin.)

Nut was primarily associated with the vault of the
heavens (she may have originally represented the Milky
Way). The vault of the heavens protected the lands of
the earth from the waters of chaos from which they had
emerged at the creation. All above, including the sun,
entered her mouth each night, traveled though her body,
and emerged renewed with the dawn.

In a similar manner she became associated with
resurrection—the dead becoming stars in her body. Indeed,
the coffin came to symbolically represent the body of Nut
from which the dead were reborn.

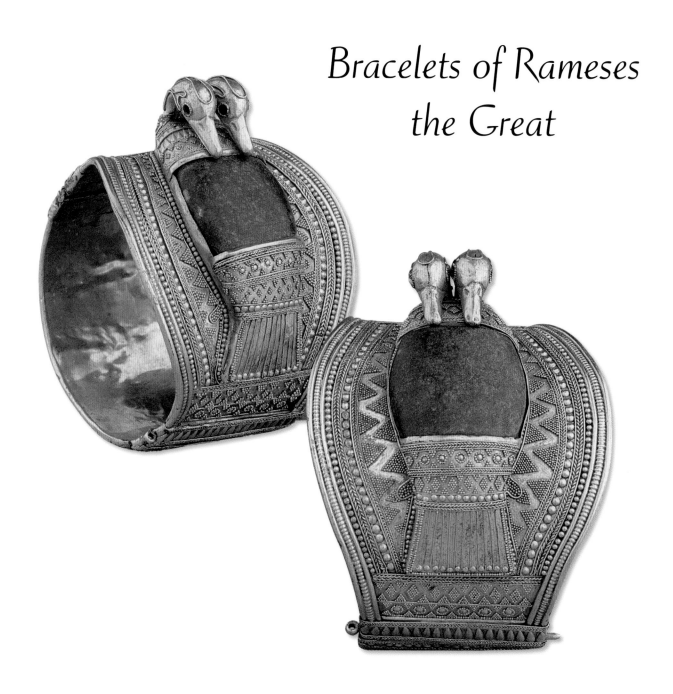

Bracelets of Rameses the Great

Materials: Gold, lapis lazuli
Dimensions: (w) 6 cm (2.36"), (outer d) 7.2 cm (2.84"),
(inner d) 6.5 cm (2.56"), (wt) 102.5 g (3.62 oz)
Current location: National Museum of Egyptian Civilization,
Cairo

Original location: Bubastis, eastern Nile Delta (discovered in 1906)
Dynasty: 19th, 1295–1186 BC, New Kingdom
Reign: Rameses II (1279–1213 BC)
Owner: Possibly Rameses II
Museum entry: JE 39873, CG 52576

Two great kings emerged in the Nineteenth Dynasty (1295–1186 BC), but the greatest jewels that have survived from the reigns of Seti I (1294–1279 BC) and Rameses II (1279–1213 BC) are buildings—the magnificent temple of Osiris at Abydos, the Great Hypostyle Hall at Karnak, the tomb of Seti I in the Valley of the Kings, the Ramesseum, the temples at Abu Simbel, and the tomb of Rameses II's Great Wife Nefertari (QV 66).

The tomb of Seti I (KV 17) was robbed in antiquity, and the tomb of Rameses II (KV 7) was also robbed in antiquity and later destroyed by flooding.

In 1906, however, railway workers dug up two collections of ancient Egyptian artifacts in Zagazig (Tell Basta, or 'Per Bastet' ['House of Bastet']), north of Cairo. This magnificent pair of bracelets bearing the cartouche of Rameses II were among the items recovered. They may have been a gift from Rameses II to the temple of the goddess Bastet, or

they may have been part of a statue to Rameses II himself.

The main body of the bracelet is formed by two hinged, gold half-cylinders closed by a pin. On the upper side lies a dome of lapis lazuli that serves as the body of two sleeping ducks or geese, who share a common tail.

The gold granule decoration around the stone—triangles and bosses with a ring of granulation around them—is extremely fine. There are larger granules around the base of the body and on the flange, and a rim resembling braided rope. Applied gold wire forms part of the decoration of the birds' heads, and their common shoulder is made of a sheet gold plate, decorated with granules of gold, which holds the stone in place at one end. The tail is a similar sheet of gold joined to a box embossed with the feather decoration.

The lower half of the bracelet is plain by contrast. The decoration consists of seventeen rows of round wires and ball beads crudely punched into the surface.

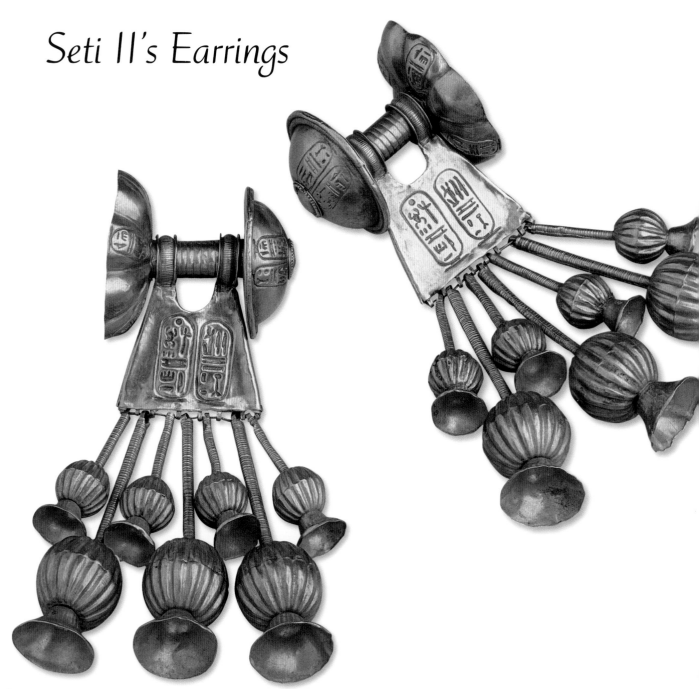

Seti II's Earrings

Materials: Gold
Dimensions: (h) 13 cm (5.12"), (w) 5 cm (1.97"), (wt) 76.75 g (2.71 oz)
Current location: National Museum of Egyptian Civilization, Cairo
Original location: KV 56 'The Gold Tomb,'

Valley of the Kings, Thebes/Luxor (excavated by Ayrton in 1908)
Dynasty: 19th, 1295–1186 BC, New Kingdom
Reign: Seti II (1200–1194 BC)
Owner: King Seti II
Museum entry: JE 39675a–b, CG 52397-8

These earrings were found—under unpromising circumstances—by Edward Ayrton in 1908. They lay in an anonymous rock-cut tomb 10 meters (32.8 feet) beneath the surface of the Valley of the Kings. The cartouche of Rameses II was present in the tomb, but most of the recovered objects named his grandson, Seti II (1200–1194 BC), and his Great Wife Tawosret (who was to reign herself—bringing the Nineteenth Dynasty to a close—between 1188 and 1186 BC). Based on the presence of a small wooden coffin and other items found, it is likely that the burial was that of a young daughter of Seti and Tawosret, and the mix of objects made for a child and those for adults perhaps reflect the suddenness of the princess's death.

The front of these royal earrings consists of a gold sheet flower with eight petals, every other petal carrying the cartouche of Seti II pushed out in relief from the underside (repoussé). The counter stud also carries the cartouches of the king, and is decorated with applied gold tubes. Suspended by loops from the tube between the studs is a trapezoidal gold pendant with the cartouches of Seti II on both sides. Below this, suspended from a ridged tube stalk, are seven cornflower pendants. The bodies of these cornflowers are made from two hollow semispherical halves soldered together. A flared plan rim has been added to complete the pendant.

The story of the following Twentieth Dynasty (1186–1069 BC) is one of the restoration of order following the reign of the female king Tawosret, but it is also the story of the constant need to defend the borders of Egypt. Rameses III (1184–1153 BC)—the last great ruler to bear that name—successfully, but temporarily, pushed back Libyan tribesmen and defeated the 'Sea Peoples' who seem to have come from southern Italy and the Aegean Sea. These wars took their toll on the economic and political life of Egypt—so much so, that Rameses III was assassinated.

After his reign, Egypt once again slowly drifted into lifelessness (though another eight kings bearing the name of Rameses were to follow him). The state was again fractured into north and south.

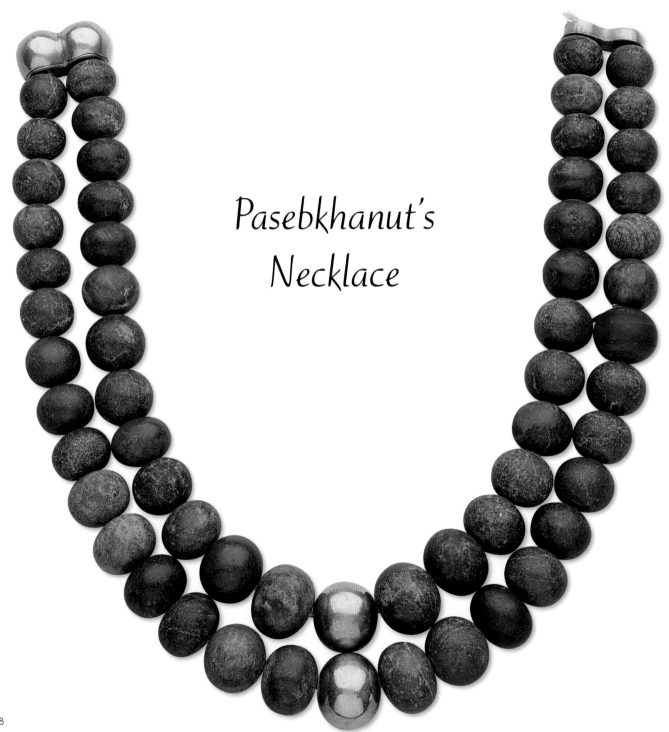

Pasebkhanut's
Necklace

Materials: Lapis lazuli, gold
Dimensions: Chain—(l) 56 cm (22.05"); beads—1.8–2.5 cm (0.71–0.98")
Current location: Egyptian Museum, Cairo
Original location: Tomb of Pasebkhanut I, Tanis

(excavated by Montet in 1940)
Dynasty: 21st, 1069–945 BC, Third Intermediate Period
Reign: Pasebkhanut I (1039–991 BC)
Owner: Pasebkhanut I (Greek: Psusennes I)
Museum entry: JE 85755, JE 85756

Soon after the death of Rameses XI (1099–1069 BC), Egypt split into two kingdom: soldier-priests of Amun in Thebes ruled the area from Aswan north to the border of the Fayum, and the north was ruled by kings from Tanis in the Nile Delta (beginning with Nesibanebdjedet I (in Greek, Smendes [1069–1043 BC]).

The burial of the third king of the Twenty-First Dynasty (1069–945 BC) was found intact in 1940. It was a far cry from the tombs of the New Kingdom kings—a stone-lined chamber for the king (Pasebkhanut I [in Greek, Psusennes I; 1039–991 BC]) and his mother, later extended to include the coffins of two of his generals. The king's mother was soon after removed to make way for King Amenemopet (993–984 BC), and the tomb was opened again to add King Sheshonq I (945–924 BC) of the Twenty-Second Dynasty (945–715 BC).

Yet the tomb of Pasebkhanut remained intact and its contents, though perhaps a little cruder than in the golden ages of Egyptian history, are remarkable.

This collar is made of two rows of fifty-six large spherical, or slightly elliptical, balls of lapis lazuli. The stone balls are graded in size, and there are two additional golden balls (around a composite core) that form the bottom of the necklace. The clasp is shaped on the top to resemble two more gold beads, and is inscribed on the underside with the name of Pasebkhanut.

Although the king is clear in an inscription on another collar that he had these necklaces made, the deep blue ball midway down the left side of the necklace (as worn) is inscribed with a three-line prayer in cuneiform—the wedge-shaped lettering system that originated in Mesopotamia—in which an Assyrian official asks his god, Assur, to protect his daughter. The meaning of this inscription in this context is unknown.

Pectoral
of Pasebkhanut

Materials: Gold, carnelian, lapis lazuli, feldspar, red jasper
Dimensions: (h) 13.8 cm (5.43"), (w) 13.4 cm (5.28"),
(wt) 351 g (12.38 oz)
Current location: Egyptian Museum, Cairo
Original location: Tomb of Pasebkhanut I, Tanis
(excavated by Montet in 1940)
Dynasty: 21st, 1069–945 BC, Third Intermediate Period
Reign: Pasebkhanut I (1039–991 BC)
Owner: Pasebkhanut I (Greek: Psusennes I)
Museum entry: JE 85796, JE 85791, JE 85795

This pectoral is broadly similar in its iconography to an earlier example found in the tomb of Tutankhamun, and was found on the mummy of Pasebkhanut I.

The kiosk is of the familiar type, but a plate has been hinged here to the bottom in the form of seventeen djed and tjet symbols of Osiris and Isis. They are inlaid with turquoise or green jasper, and carnelian, and each is crowned with a sun disk.

Below the cornice of the kiosk at the top of the pectoral is the *pet* sign for 'heaven' in lapis lazuli.

Inside the kiosk, the goddess sisters Nephthys (left) and Isis (right)—traditional protectors of the dead—sit on either side of a winged scarab. Their bodies are made of carnelian, and their arms out of turquoise. Their hair is gold. Rather clumsily, their titles rest on their arms on inserted gold plates—Nephthys is also saying, 'We have come to protect you.' The lapis lazuli scarab—with its associations of resurrection—lies above the name of the king, while the name he took at his coronation appears above, also in a cartouche. The wings of the scarab are inlaid with large strips of carnelian, turquoise, and lapis lazuli (or, possibly, glass), which have been scored to create detail.

A winged sun disk flies above the scene, with two rearing cobras hanging below to protect the name of the king. In the remaining space in the corners are two more rearing cobra *uraei* wearing sun disks.

The reverse is etched in the same pattern, but the bottom of the scarab is surrounded by an oval window allowing the names of the king to be seen on the base.

The counterpoise associated with this pectoral is inlaid in the same manner as the wings of the beetle.

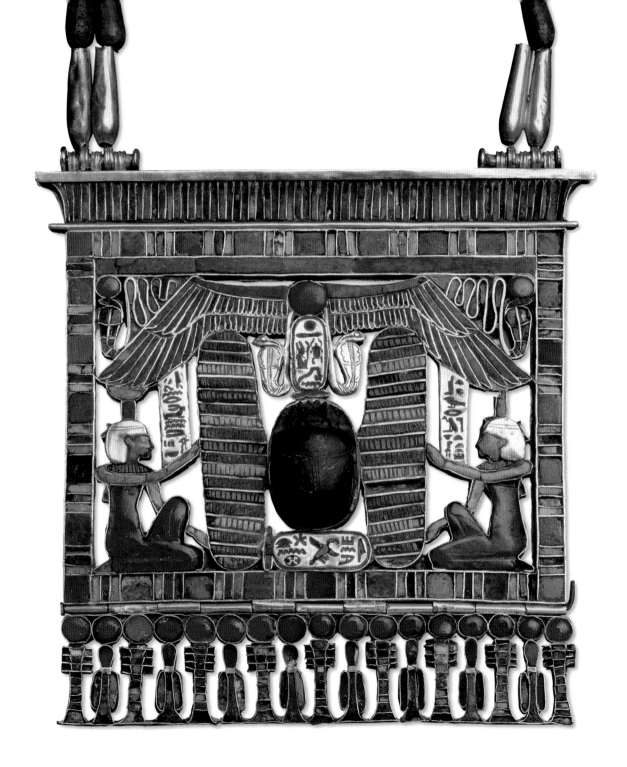

A General's
Pendant

Materials: Gold
Dimensions: (h) 7.2 cm (2.84")
Current location: Egyptian Museum, Cairo
Original location: Burial of Undjebauendjed.
Tomb of Pasebkhanut I, Tanis

(excavated by Montet in 1946)
Dynasty: 21st, 1069–945 BC, Third Intermediate Period
Reign: Pasebkhanut I ('Psusennes,' 1039–991 BC)
Owner: General Undjebauendjed
Museum entry: JE 87718

Almost 1,500 ancient Egyptian gods and goddesses are known by name, though we know very little else about many of them. Indeed, the Egyptians themselves regarded even the most important deities as 'unknowable,' 'hidden,' or 'mysterious.' The forms in which they might be represented—sometimes many forms for a single god or goddess—simply acted as a means of ritual or personal devotion. They were not meant to represent what the divine figure, with his or her many attributes and powers, might actually look like.

One source of inspiration concerning what a god or goddess *might* look like was the natural world, of which the ancient Egyptians were the keenest of observers. However, there were not enough animals in Egypt to describe every one of the legions of gods or goddesses.

This fine solid gold pendant—one of six on a single cord—was found on the chest of General Undjebauendjed, whose grave had been inserted in the tomb of his king, Pasebkhanut I. It is sometimes identified as the fierce goddess Sekhmet, but it is likely that the goddess Bastet was intended, as it is described in the records of the Egyptian Museum. The evidence supporting this identification of one lioness-headed goddess over another is simply that two other identical figurines from the same burial are specifically identified in hieroglyphs as Bastet.

Bastet was generally regarded as having a milder nature that the more unpredictable Sekhmet, and gradually assumed the form of a cat or cat-headed goddess—almost exclusively after the New Kingdom. In this form, she was regarded as a mother and nurse of the king, and, more generally, as a symbol of motherhood who protected women in pregnancy.

The cat was also venerated for its fertility, to which anyone who has lived in modern Egypt can still attest, and Egyptian faience amulets of the seated cat goddess with her kittens were popular forms of jewelry.

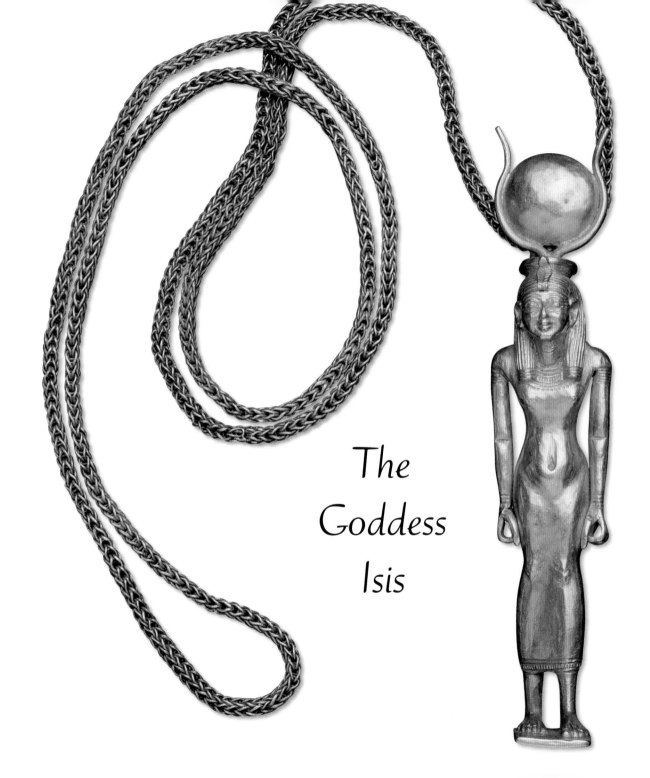

The
Goddess
Isis

94

Materials: Gold
Dimensions: (h) 11 cm (5.28")
Current location: Egyptian Museum, Cairo
Original location: Burial of Undjebauendjed.
Tomb of Pasebkhanut I, Tanis

(excavated by Montet in 1946)
Dynasty: 21st, 1069–945 BC, Third Intermediate Period
Reign: Pasebkhanut I ('Psusennes I,' 1039–991 BC)
Owner: General Undjebauendjed
Museum entry: JE 87716

Although there are no certain references to the goddess before the Fifth Dynasty (2494–2345 BC), the worship of Isis was to spread far further than that of any other Egyptian deity. In the Roman world, she was to be worshiped from Afghanistan in the east to the cold, gray, wet shores of Britain in the west. She was more celebrated than her consort Osiris, and her temple at Philae was the last major refuge of the old gods to survive after Egypt became predominately Christian. The principal basis for her fame was her personal relationship with those who communicated with her, a relationship that extended from this life into the afterlife.

Over time, the goddess acquired many attributes from other goddesses, and in this lovely solid gold pendant she wears a sheath dress, and the horns and sun disk of the goddess Hathor. An inscription on the base, however, confirms her identity: 'Isis, mother of the god.'

It was Isis who had mourned inconsolably upon the death of her husband Osiris at the hands of the god of chaos Seth, and it was she who, through magic, revived Osiris, which resulted in the birth of their son Horus.

Isis steadfastly cared for her young son, using her magic again and again to heal him from sickness. She also removed other dangers that lay in the path of his avenging the death of his father and taking the throne of Egypt. All Egyptian kings could trace their lineage back to the mythological rule of Horus, and Isis was, therefore, symbolically also the mother of the king and the personification of the power of the throne (the hieroglyphic symbol for which sits upon her head in other images of her).

Her magical ability to protect and heal those who invoked her name was central to her popularity among the living. These characteristics—alongside those of her sister Nephthys—were also a major component of her expected role among the dead, where she was considered to be a mourner, sustainer, and protector. Isis was thought to care for the dead—in the manner of a devoted mother—as she had cared for her own child.

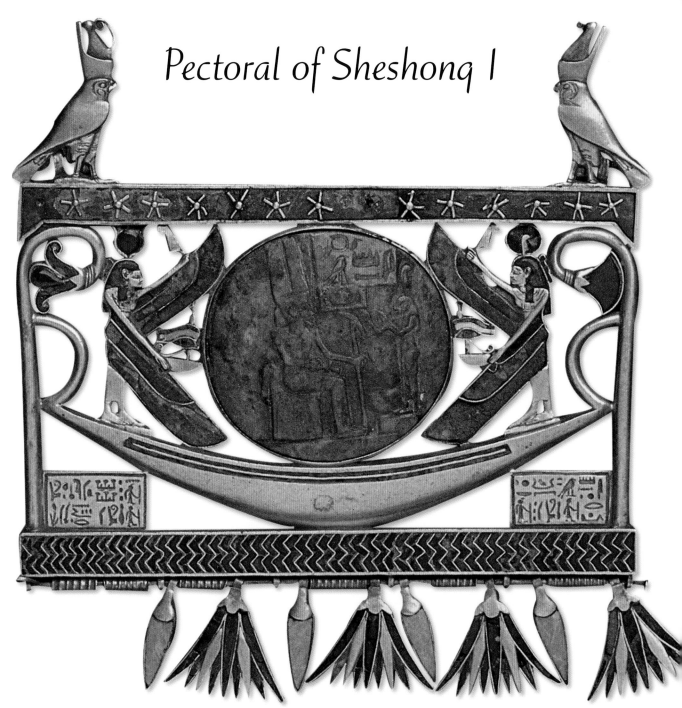

Pectoral of Sheshonq I

Materials: Gold, lapis lazuli, glass paste
Dimensions: (h) 7.7 cm (3.03″), (w) 8.4 cm (3.31″),
(wt) 76.7 g (2.71 oz)
Current location: Egyptian Museum, Cairo
Original location: Burial of Sheshonq II, tomb of Pasebkhanut I,

Tanis (excavated by Montet in 1939)
Dynasty: 22nd, 945–715 BC, Third Intermediate Period
Reign: Sheshonq I (945–924 BC)
Owner: Sheshonq II (around 890 BC)
Museum entry: JE 72171

After the reign of the kings of Tanis came to an end around 945 BC, a new dynasty (945–715 BC) was established by kings of Libyan origin. It is likely that the families from which these kings were drawn had lived in the Nile Delta for generations—there is no evidence of an invasion from the west.

Sheshonq I (945–924 BC) was the first of the Libyan pharaohs who was to rule the north, and he established a new capital at Bubastis in the Delta. By installing one of his own sons, Iuput, as high priest of Amun at Karnak, the king was able to establish a measure of control over the south as well.

This slightly damaged pectoral of Sheshonq I takes the form of a gold bark of the sun floating on water. The prow and stern of the boat take the form of the lily (in lapis lazuli and carnelian) and papyrus flower (in lapis lazuli), representing Upper and Lower Egypt. An articulated frieze of lotus flowers and buds hangs below the pectoral.

Gold representations of the goddess of truth and justice Maat, and of Hathor (or Isis) with cow horns and a carnelian sun disk, support a central lapis lazuli sun disk with inlaid wings. Both carry gold *maat* feathers (against which the heart of the deceased will be weighed), and between their wings lies a protective *wedjat* 'Eye of Horus' above the *neb* ('every,' 'all') and *nefer* ('good,' 'beautiful,' 'happy') signs.

Within the sun disk sits the sun god Amun-Re, who is presented with offerings by the goddess Maat.

The two inscriptions ask for the protection of Amun-Re for Sheshonq as the great chief (the 'great of the great ones') of the Ma (a Libyan tribe), and describe the scene: 'You [Amun-Re] spend the day in your bark, your heart happy while Maat appears before you.'

The image is completed at the top by a lapis lazuli *pet* sign for 'heaven' complete with stars. Above this sit two falcons wearing the double crown of Egypt.

Sheshonq's *Wedjat* Bracelets

Materials: Gold, lapis lazuli, carnelian, Egyptian faience
Dimensions: (h) 4.6 cm (1.81″), (d) 7 cm (2.76″),
(wt) 120.4 g (4.25 oz)
Current location: Egyptian Museum, Cairo
Original location: Burial of Sheshonq II, tomb of Pasebkhanut I,
Tanis (excavated by Montet in 1939)
Dynasty: 22nd, 945–715 BC, Third Intermediate Period
Reign: Sheshonq I (945–924 BC)
Owner: Sheshonq II (around 890 BC)
Museum entry: JE 72184b

Also buried in the tomb of Sheshonq II were these exquisite bracelets belonging to Sheshonq I—presumably they were an heirloom. They are made of two unequal parts that are hinged and closed with retractable pins. The cartouches of Sheshonq I appear on the otherwise plain insides of the bracelets.

They are decorated with a right eye for the right wrist and a left eye for the left wrist against a background of light-colored lapis lazuli (the left eye of Horus represented the moon, and the right eye the sun).

The eyes are made of white faience with a black stone iris, and the eyebrow and the eye linings are made of lapis lazuli inlay surrounded by gold. Both eyes rest on a *neb* basket inlaid with small squares of lapis lazuli, carnelian, and gold, perhaps ensuring 'every' protection.

The remainder of the decoration is composed of vertical pieces of gold and lapis lazuli, and the borders are made from rectangular patterns made from carnelian and (possibly) lapis lazuli.

The familiar *wedjat* (meaning 'the sound one') symbol represents the eye of the falcon-headed god Horus after it had been plucked out by the god Seth and healed by the ibis-headed god of knowledge and magic (among many other things), Thoth.

Horus was said to have offered the healed eye to his dead father, and its magic was so powerful that it restored Osiris to life.

The *wedjat* is found in great numbers as an amulet placed on mummies, but it was also worn in life as a protective symbol. The drop shape at the front of the eye, and the spiral to the rear, are said to imitate the markings of the lanner falcon.

Pectoral of Sheshonq II

Materials: Gold, semi-precious stones, glass paste
Dimensions: Chain—(l) 78 cm (30.71"), (wt) 503.7 g (17.77 oz);
pectoral—(h) 16 cm (6.30"), (w) 18.5 cm (7.28")
Current location: Egyptian Museum, Cairo
Original location: Burial of Sheshonq II, tomb of Pasebkhanut I,

Tanis (excavated by Montet in 1939)
Dynasty: 22nd, 945–715 BC, Third Intermediate Period
Reign: Sheshonq II (around 890 BC)
Owner: Sheshonq II
Museum entry: JE 72170

This pectoral was carefully placed over the heart of Sheshonq II.

The kiosk around the central image is constructed from blocks of gold and glass paste. Inside the cornice is a winged sun disk, and below hangs a gold plate with engraved *djed* and *tjet* symbols.

In the center, the figures of Nephthys and Isis kneel while supporting a winged scarab (symbolic of resurrection), above and below which are the cartouches of the king. Much of the inlayed cloisonné work in colored Egyptian faience has now decayed, but it remains a dramatic piece.

The whole scene is capped by another winged scarab from which hangs two rearing cobra *uraei*.

In the center of the pectoral is a large heart scarab of dark green stone enclosed in a band of gold. The material from which a heart scarab should be made was prescribed as a green stone (*nemehef*)—possibly meaning green jasper or serpentine, but here the stone is glazed steatite (soapstone).

Visible on the underside of the scarab is a spell (30B) from the *Book of the Coming Forth by Day* (known in modern times as the *Book of the Dead*) that commands the heart not to lie about the deceased when it is weighed against the feather of Maat.

In summary it says:

'O my heart! Do not stand up as a witness against me. Do not be opposed to me in the tribunal [of the gods], do not be hostile to me in the presence of the Keeper of the Balance [the jackal- or dog-headed funerary god Anubis, who set the scales that weighed the heart and feather of Maat], for you are my ka [soul] which was in my body, the protector who made my limbs healthy. Go to the happy place to which we speed, do not make my name stink to the Entourage who make men. Do not tell lies about me in the presence of the god. It would be best if you listen to me!'

Pendant Head of Hathor

Materials: Gold, lapis lazuli, glass paste
Dimensions: (h) 5.5 cm (2.17"), (w) 5.3 cm (2.09")
Current location: Grand Egyptian Museum, Cairo
Original location: Tomb of High Priest Sheshonq,
Memphis/Mit Rahina

(excavated by Badawy in 1942)
Dynasty: 22nd, 945–715 BC, Third Intermediate Period
Reign: Osorkon II (874–850 BC)
Owner: Sheshonq, high priest of Ptah at Memphis
Museum entry: JE 86780, GEM 2360

As Sheshonq I had done in Thebes, Osorkon II (874–850 BC) did in Memphis, establishing his heir Sheshonq as High Priest of the god of craftsmen and creator god, Ptah, whose consort was Sekhmet. Prince Sheshonq predeceased his father, however, and was buried in Memphis.

Among the pieces recovered, this lovely pendant of the goddess Hathor—complete with cow's ears—is made of lapis lazuli and inlaid with gold. The eyes are made of glass paste.

Hathor may have been worshiped before Egypt was united, but was certainly known by the time of King Djer. She served a large number of roles, the principal one being—as the 'beautiful one'—the goddess of femininity (including love, sexuality, and motherhood).

Hathor was closely associated in a motherly role with the king. The king was the descendant of Horus, whose mother or wife (in one version of the story) she was said to be. By extension, she was also the 'wife of the king' and, from the Fourth Dynasty onward, the king's principal wife served as Hathor's priestess, and was viewed to some degree as the physical presence of the goddess. The splendid Small Temple made for Queen Nefertari by Rameses II at Abu Simbel is a clear example of this relationship.

While we cannot delve into the many other attributes of Hathor here, it should be mentioned that she was the goddess who protected foreign trade and, particularly as the 'Mistress of Turquoise,' the quarries from which many of the semi-precious stones illustrated in this book originated. Based on the similarity in color of the material, Hathor was also often referred to as the 'Mistress of Faience.'

While the Libyan kings were to remain a force in the north for another century after the death of Osorkon II, Egypt was rapidly fragmenting. By about 820 BC, additional kingdoms separating Tanis and Thebes emerged. Even in the Delta itself the rise of semi-independent princedoms, some of which became hereditary, helped sow the seeds that would bring about the end of ancient Egypt. This lack of cohesion immediately provided an opportunity for armies from beyond the southern border.

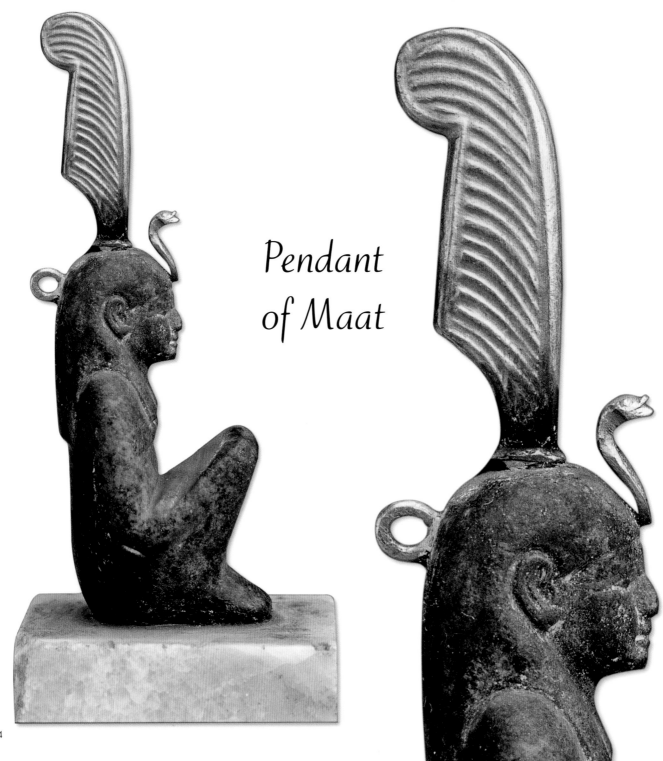

Pendant
of Maat

Materials: Lapis lazuli, gold
Dimensions: (h) 7.2 cm (2.84"), (w) 2.5 cm (0.98"),
(depth) 2.cm (0.79")
Current location: Grand Egyptian Museum, Cairo
Original location: Possibly Khartoum, Sudan

(purchased from the Huber Collection)
Dynasty: 25th, 747–656 BC, Late Period
Reign: Possibly Piye (747–716 BC)
Owner: Unknown
Museum entry: JE 5189, CG 38907, GEM 2373

Almost everything about this lapis lazuli and golden pendant of the goddess Maat is uncertain. It may have been found near Khartoum in Sudan, and simply judging by the features, it may be Nubian, but it may also be Egyptian.

The similarity to a malachite and silver pendant in the Museum of Fine Arts, Boston—known certainly to have come from Nubia and to date from the beginning of the Twenty-Fifth Dynasty (747–656 BC) at the start of the Late Period (747–332 BC)—suggests that this piece is of approximately similar date, as it is entered in the records of the Egyptian Museum in Cairo. Whatever the case, the pendant serves the purpose of reminding us that the Kushite kings—who took control of Egypt during the Twenty-Fifth Dynasty—were the inheritors of a deep relationship of many centuries between Nubia and Egypt.

Indeed, the Kushite kings had come to believe that they were the rightful heirs to Egyptian religious, and hence royal, authority. This seemingly unshakable belief was in part based on the presence of the great temple dedicated to Amun at Gebel Barkal within their Nubian homelands.

The presence of this representation of the goddess Maat in Nubia—her arms hidden by her robe, but wearing her distinctive feather and the rearing cobra *uraeus*—serves also a reminder that *all* followers of Egyptian beliefs were bound by the principles that the goddess personified—truth, justice, and the maintenance of cosmic order (or *maat*). The king, himself, was a 'brother' of the goddess Maat as they shared the same 'father,' the sun god Re, and the entire legitimacy and legacy of his reign would be judged by his ability to uphold *maat*.

As we have seen, passage to the Otherworld was decided by whether the deceased's deeds in life had sufficiently upheld the principles of *maat* that their heart weighed less than the feather worn by the goddess.

The Kushite kings ruled Egypt for a little less than a century. King Taharqa (690–664 BC) ultimately failing to repulse Assurbanipal of Assyria (668–627 BC), who invaded Egypt in 666–665 BC.

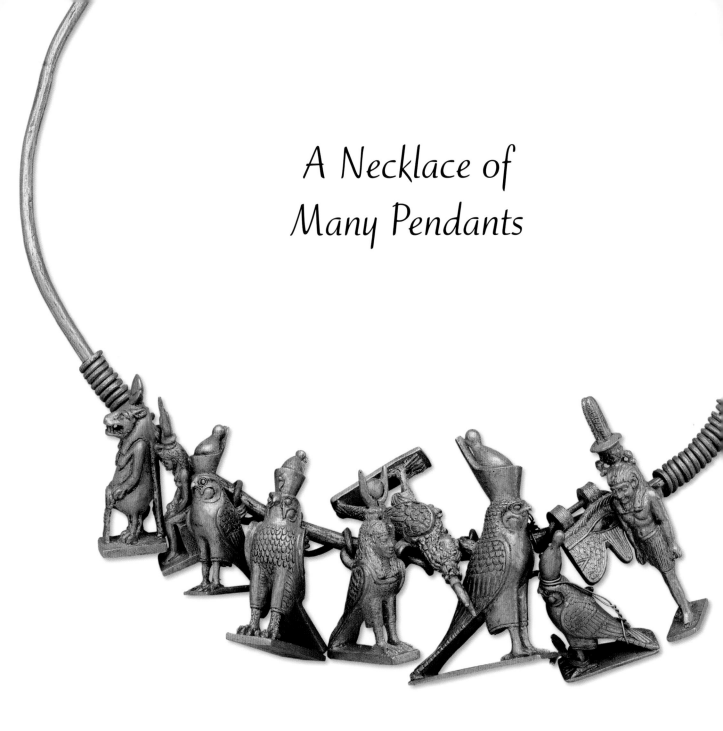

A Necklace of
Many Pendants

Materials: Gold
Dimensions: Ring — (d) 12.5 cm (4.92"), (wt) 169 g (5.96 oz);
pendants — 1.3-3.8 cm (0.51–1.50")
Current location: Egyptian Museum, Cairo
Original location: Temple of Hathor, Dendera

(confiscated in 1912)
Dynasty: Hellenistic Period (332–30 BC)
Reign: Unknown
Owner: Unknown
Museum entry: JE 45206, CG 53188

The Egyptian kings who owed allegiance to the Assyrians to varying degrees during the Twenty-Sixth (Saite) Dynasty (672–525 BC) were defeated by the Persians under Kambyses (525–522 BC), and Persian kings ruled Egypt directly between 525–404 BC. After another brief Egyptian resurgence during the Thirtieth Dynasty (380–343 BC), a second period of direct Persian rule (343–332 BC) was ended by Alexander the Great (356–323 BC)—who inaugurated the Hellenistic Period (332-30 BC).

From Ptolemy I (305–282 BC) to Kleopatra VII (51–30 BC), the kings and queens of the Ptolemaic Period quickly realized that, in order to rule, they must gain and keep the allegiance of the Egyptian priesthood, and, through them, the allegiance of the people.

This necklace of solid gold pendants was confiscated by the Egyptian authorities in 1912, but it is believed to have come from the Ptolemaic temple of Hathor at Dendera. It demonstrates the opulence of an item that may have belonged to a priest at the temple during the Ptolemaic Period, while managing to simultaneously appear, rightly or wrongly, a little confused.

A thick wire supports ten pendants, and closes, when bent, by means of two hooks. The heavy pendants are prevented from moving by a second wire wound through the back of the pendants, the ends of which are formed in a spiral.

From left to right, the pendants are of the hippopotamus goddess of pregnancy and childbirth Taweret; a seated figure of the goddess Isis; a manifestation of the falcon god Horus wearing the double crown of Egypt; a second Horus figure with wings and tail that were originally inlaid; a bird with a human head representing the *ba* component of the soul that survives death and encompasses the personality of the individual; a second *ba* figure; a third falcon figure wearing the double crown of Egypt; a fourth falcon figure wearing only the white crown of upper Egypt; and a *wedjat* eye of Horus. Finally, there is a representation of the god Nefertem (with a lotus bud on his head). Nefertem was an ancient god and represented, in one of the Egyptian creation myths, the lotus bud that arose from the primeval waters and from which, when the bud opened, the sun god arose.

A Young Woman's Jewelry

Even a very concise history of the Ptolemaic Period is too complex to be related here, but, characteristically, it involved intrigue, murder, absconding with the treasury, and intense political maneuvering in a world of increasing hostility—most of that hostility arising from the rapidly expanding Roman Republic across the Mediterranean.

As is well known, the end came as the undeniably clever Cleopatra (Kleopatra VII, 51–30 BC) and the Roman aristocrat Mark Anthony were finally cornered by the adopted son of Julius Caesar, Octavian (63 BC–AD 14)—who became Emperor Augustus in 27 BC and claimed Egypt as his imperial property.

During the first three hundred years of Roman Egypt, mummification of those who could afford the process continued. Particularly, but not exclusively, in the Fayum—a low-lying fertile area beginning 100 kilometers (sixty-two miles) southwest of Cairo and west of the Nile—a painted portrait of the deceased in the Greek naturalistic style was often attached to the mummy in the form of a wooden panel fitted into the wrappings.

The best of these 'Fayum Portraits,' such as this one of a young woman named Demos, were probably painted in life by artists of the Alexandrian school. These images allow us to appreciate what some members of the Greco-Roman community may have looked like at the end of the first century AD.

Demos, who wears a purple Greek *chiton* with a black stripe, also had elaborately dressed hair. She had tight curls and a spiral plait held in place with a long gold hairpin with a hooked end. She wears earrings of Greek design that are quite different from the examples we have seen earlier—a curved pin, hidden by her hair, supports a gold bar, with a pearl at the center, from which hang three gold chain pendants ending in a pearl.

Her necklace is composed of two rows of emeralds separated by a gold chain.

Although pearls were known from the Red Sea coast, and mother-of-pearl was occasionally used in ancient Egypt, it was only after the Persians arrived that they began to be much used in jewelry. Only with the arrival of the Ptolemies were they used frequently.

Similarly, although emeralds (green beryl) can be found in Egypt in mines to the south of Marsa Alam, the hardness of the stone meant that it was used rarely in jewelry even into the late Ptolemaic period, and became common only in the Roman Period.

Materials: Encaustic painting over wood
Dimensions: (h) 38 cm (14.96"), (w) 21 cm (8.27"), (depth) 0.2 cm (0.08")
Current location: Egyptian Museum, Cairo
Original location: Hawara, Fayum (excavated by Petrie in 1888)
Dynasty: Roman Period (30 BC–AD 395)
Reign: Emperor Domitian (AD 81–96), Emperor Nerva (AD 96–98), or Emperor Trajan (AD 98–117)
Owner: Demos (around AD 75–100), 'Demos, aged 24, remembered forever.' Demos was buried together with a young daughter.
Museum entry: CG 33237

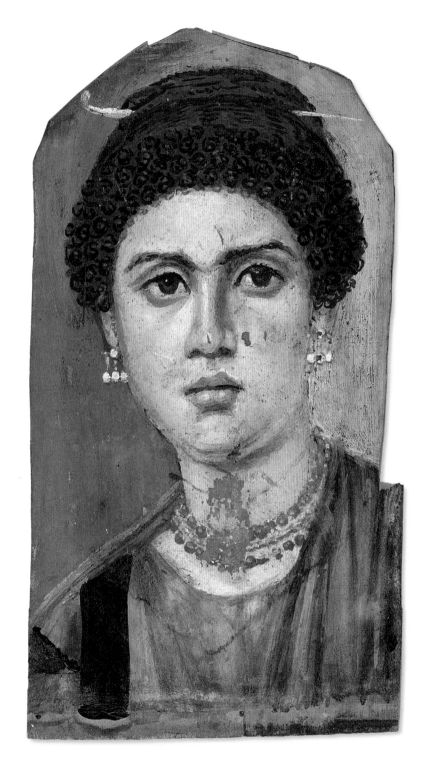

Diadem of Serapis

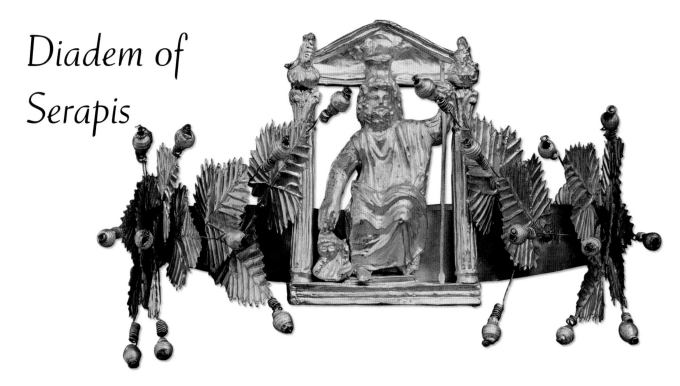

This gold leaf diadem was found in the temple of Osiris, Isis, and Serapis in Kharga Oasis, 200 kilometers (125 miles) west of the Nile and to the south of the country. It probably belonged to a priest of the temple during the reign of the Egyptophile emperor Hadrian (AD 117–38).

The diadem consists of seventeen gold leaves and twenty gold beads on spiral gold branches surrounding a shrine with Corinthian columns. Within the shrine sits the figure of the god Serapis with a full beard and a *kalathos* 'basket' crown of fertility and plenty on his head. He holds a lance in his left hand, and his right hand rests (perhaps) on the head of the eastern god Mithras.

This new god was an extraordinary mixture of Egyptian and Greek deities, introduced during the reign of Ptolemy. Worship of Serapis was deliberately intended to form a bridge between the two religious traditions.

Serapis's origins in fact predated the arrival of the Greeks in Egypt as a combination of the gods Osiris and Apis (a bull god—the herald of Ptah at Memphis—whose origins stretched back to the beginnings of Egypt), but to this native mixture were added attributes of the Greek gods Zeus, Helios, Dionysus, Hades, and Asklepius to form a new, great god of the sun, the afterlife, and healing. The consort of Serapis was sometimes thought to be Isis, and

Materials: Gold leaf
Dimensions: Diadem — (d) 22 cm (8.66"), (wt) 363.3 g (12.82 oz); plaque — (h) 12.5 cm (4.9"), (w) 8.5 cm (3.35")
Current location: Egyptian Museum, Cairo
Original location: Temple of Osiris, Isis, and Serapis, Dish,

Kharga Oasis (excavated by Reddé in 1989)
Dynasty: Roman Period (30 BC–AD 395)
Reign: Emperor Hadrian (AD 117–38)
Owner: Priest of Serapis
Museum entry: JE 98535

with her, the fame of Serapis spread throughout the Roman Empire. However, despite the great temple to Serapis at Alexandria, which was regarded as a wonder of the Mediterranean world, it seems that the Egyptian people, who continued to prefer their traditional gods and goddesses, never wholly adopted the new god.

By contrast, the lovely island temple of Isis at Philae (near Aswan) continued to be famous as a place of pilgrimage not only throughout the Roman world, but also among Egyptians who followed the old ways.

Yet, particularly along the northern Mediterranean coast, it was not to be long before the knowledge of the sacred meanings of hieroglyphs and religious inscriptions were completely lost—until they were rediscovered again in the early nineteenth century—though the letters and words might still be used to create unintelligible inscriptions. In places, recalled images of the resurrection myths of Osiris and Isis appeared alongside the myths of Hades and Persephone.

In the Roman period, the process by which ancient

Egyptian traditions were forgotten was accelerated by the spread of Christianity from Alexandria—a process that is said to have begun with the arrival of Saint Mark in Egypt around AD 50.

The Christians of Egypt gradually defaced or destroyed the last remnants of the old religion. They converted some of the ancient buildings into churches (which ironically saved them for later generations to see), or they simply left them to the ever-encroaching desert sands.

The last Egyptian temple to be closed, after Emperor Theodosius (AD 392–95) declared the Roman Empire to be Christian in AD 393, was the temple of Isis at Philae where, pathetically, the last dated hieroglyphic inscription, of 24 August AD 394, can still be seen.

A few amulets continued to survive in this new wider Christian world—including the ankh (adopted as a form of the Christian cross)—but soon the three-thousand-year history of distinctive ancient Egyptian jewelry-making, the magic that inspired it, and the magnificent civilization which supported its craftsmen, simply faded away.